"Whoever makes a design without the knowledge of perspective, will be liable to such absurdities as are shown in this frontispiece."

SATIRE ON FALSE PERSPECTIVE
from the original drawing by HOGARTH

Hogarth del.t Le Cœur sc.

perspective **DRAWING**

JOSEPH WILLIAM HULL

DOVER PUBLICATIONS, INC.
Mineola, New York

Bibliographical Note

This Dover edition, first published in 2010, is an unabridged republication of the work originally published by the University of California Press, Berkeley and Los Angeles, in 1950 under the title *Perspective Drawing, Freehand and Mechanical.*

Library of Congress Cataloging-in-Publication Data

Hull, Joseph William, b. 1897.
 [Perspective drawing, freehand and mechanical]
 Perspective drawing / Joseph William Hull. — Dover ed.
 p. cm.
 Originally published: Perspective drawing, freehand and mechanical. Berkeley :
University of California Press, 1950.
 Includes bibliographical references.
 ISBN-13: 978-0-486-47399-4
 ISBN-10: 0-486-47399-6
 1. Perspective. I. Title.

NC750.H94 2010
742—dc22

2009009001

Manufactured in the United States by Courier Corporation
47399601
www.doverpublications.com

TO MY WIFE
LOIS VIRGINIA

PREFACE

This book is offered to those who are interested in the visual phenomenon, "Things do not appear as they actually are." In order to understand the nature of this peculiarity of sight as applied to drawing, it is necessary to study and practice the science of perspective.

To promote an understanding of the versatile nature of perspective drawing, and to teach the subject by a functional method, this book is designed in two parts. The first part encourages the student to begin immediately to draw, freehand, and to gain knowledge of the principles of perspective as he acquires mastery of his tool, the pencil. Practical illustrations of freehand drawing of various kinds are offered in the representational or perspective manner, and the student is shown the value of applying perspective to such problems as the representation of light and shade and the drawing of textured objects—imaginary as well as existing forms. To be able to draw an object-to-be, in full light and shade, in the most dramatic or effective position possible and to have the confidence to express oneself originally and intelligently are obviously desirable achievements. The first part of this book is designed to fulfill these objectives.

The second part deals exclusively with the laws, principles, and theory that constitute the science of perspective. A perusal of the Contents will indicate the wide scope of Part Two, in which the mechanics of perspective are set forth thoroughly and yet simply. Part Two is intended as an auxiliary to the drawing instruction and is therefore organized for ready reference as the student progresses through Part One.

The term "perspective" is a familiar one. The word is derived from the Latin *perspicere*, "to see through." To be able to "see through" an object, in the sense applicable to perspective drawing, will enable the student (1) to achieve an awareness of the structural character of an object or group of objects, the relationship to space within themselves, between one another, and between them and infinity; (2) to overcome one of the most common of technical difficulties encountered in representational or perspective drawing, that of achieving an accurate, and therefore convincing, drawing of the foreshortened surface; and simultaneously to develop his consciousness of the relative proportions of objects as they appear; (3) to practice mental discipline leading to deliberate, critical observation and precise thinking about the objects to be drawn; and (4) to develop a highly sympathetic coordination of eye, mind, and hand, so necessary in precision drawing.

Perspective has been and still is of special interest to

persons whose vocational objectives lie in such important areas of art as architecture, landscape architecture, city planning, industrial design, including the whole range of manmade objects used in daily life, and commercial or advertising illustration.

Science, too, is interested greatly. The scientific illustrator needs to practice perspective in many fields: the numerous branches of the life sciences, physics, chemistry, geology with its surveys and projects, geography, and—one of the most exacting of all—medical illustration.

People in these professions must, of necessity, learn to see, to observe, accurately. But the ability to draw what one sees as it actually appears to the human eye is of value to persons in any walk of life, for the skill becomes an added means of communication and also a cultural hobby for those who like to draw for pleasure.

It has been well said that to be able to draw is not a gift from the gods. The skill may be acquired by realizing to what degree things *do* appear different from what they are and by practicing diligently and faithfully under competent guidance. One sure way to learn to draw is to keep on drawing. The student should use his knowledge of the laws of perspective in conjunction with the freehand way of drawing, especially when the character of the drawing is representational. He will find that the convincing graphic statement which results will be a source of great satisfaction.

The author wishes to express his deep appreciation to those of his colleagues, friends, and students whose drawings are included among the illustrations of this manual; specifically, to S. Macdonald Wright, Professor of Fine Arts, University of California, Los Angeles, for original pencil drawings (pp. 17, 22, 36, 37, 42, 48, 65–67); to Carleton Monroe Winslow, Jr., A.I.A., Architect, Beverly Hills, California, for his original architectural renderings in pencil (pp. 61–63); to Mrs. George James Cox, Isle of Wight, England, for gracious permission to use the reproductions of two wood engravings by her late husband, George James Cox, R.C.A., Professor of Fine Arts, University of California, Los Angeles (p. 49); to Mrs. Arthur Monrad Johnson, Los Angeles, for her kind permission to use scientific illustrations by her late husband, Dr. Arthur Monrad Johnson, Professor of Botany, University of California, Los Angeles (pp. 54–58); to Mr. Robert Greenberg, member of the teaching staff of the University of California, Los Angeles, for execution of the cover and half-titles; and to the following students of the University of California, Los Angeles, for a number of drawings in pencil and a few in pen and ink: Mr. Van Chamy, Miss June Draper, Mr. Fred Guiol, Mr. Dean P. Hemphill, Mr. Ronald R. Keller, Mrs. Primilla May, Mr. John F. McKim, Mr. Paul K. McKissock, Miss Donnadeane D. Reemes, Mr. Martin Silverman, Miss Phyllis O'Connor, Miss Olga Seem, Mr. P. Stange,

Mr. Marty C. Trent, and Miss Aileen Yonover.

Selections of student work were made from routine class assignments in beginning drawing. Fundamentals were stressed, but self-expression and the development of original style were encouraged.

The author also wishes to express his appreciation to Harold A. Stump, Assistant Professor of Architecture, University of California, Berkeley, and to the editor of this manual, Miss Helen I. Travis, of the University of California Press, for their valuable consultation, constructive suggestions, and enthusiastic cooperation.

Joseph W. Hull

University of California
Los Angeles Campus
June, 1950

CONTENTS

PART TWO: THEORY, BASIC LAWS, AND PRINCIPLES OF PERSPECTIVE

PLATES

INTRODUCTION

In the early history of mankind, the contours of objects were primary to the artist in his endeavors to express graphically his conceptual experiences in the three-dimensional world. He had a deep conviction that objects owed their existence only to the boundaries enclosing them. The phenomenon of a separate ocular world with laws of its own was probably little known to him. As a result, a lack of physical or environmental contact within the picture produced, in the main, the "flat" or two-dimensional effect characteristic of archaic drawing and painting.

That the illusion of solidity of three-dimensional representation might have been in his consciousness to some degree is plainly manifest, however, in his early cave drawings and paintings, some of which are reproduced on page 2. In his line drawings, *Charging Mammoth* (Pl. II) and *Reindeer and Salmon* (Pl. I), one sees what may have been an attempt at modeling—that is, the use of shading or tonal values—to record surface textures so as to suggest the third dimension. Such an attempt is more demonstrable in the picture, *Running Boar* (Pl. III), the original of which

is in pleasing colors of reds, blacks, and browns. Here is, probably, a conscious use of modeling to achieve an effect of solidity. The foreshortening felt in *Running Boar* was achieved by the elliptical nature of the rounded surfaces of body and hoofs, and also by giving the pictured animal a position in space a bit to the right of and above that of the observer. In other words, the artist chose a position at which drawing the object as seen would require the use of foreshortening. Also, in looking at the drawing of the salmon, one is reminded that the fish body is elliptical, by virtue of the scale treatment. Such a technique on the part of these early artists indicates that they may have drawn from life rather than according to their concepts of the real nature of the objects, as some critics have held.

Skill in representational drawing requires development of coördination of the eye, the mind, and the hand, regardless of natural aptitudes. Those possessing native ability may require less training; however, not many people can simply "draw what they see" without an understanding of the facts of foreshortening.

Cave Pictures

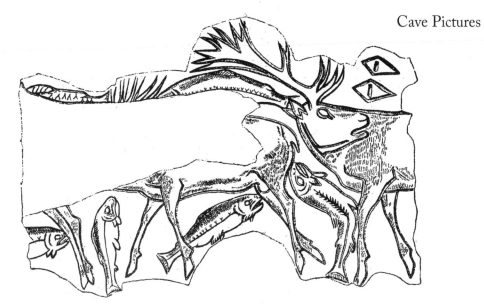

Plate I. Early Magdalenian Period,
Reindeer and Salmon

Plate II. Early Magdalenian Period,
Charging Mammoth

Plate III (right). Middle Magdalenian Period,
Running Boar

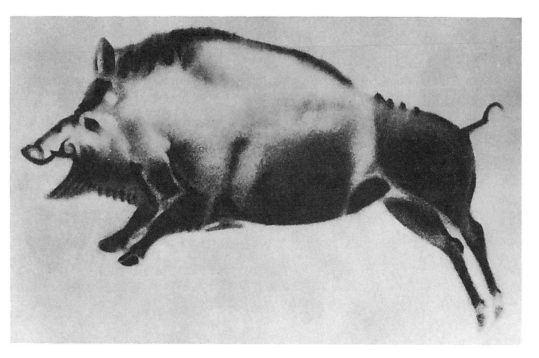

1. Origin and Development of Perspective

The first recorded attempt to understand perspective appears to be the treatment of the subject by Euclid in his *Optics,* written about 300 B.C. This fact reminds us of the inseparable relationship between perspective and the optic mechanisms, the nature of which creates the stereomorphic, or solid, three-dimensional illusion that we endeavor to transfer to our two-dimensional drawing paper.

The next literary record on the topic of perspective after Euclid's time was a part of a treatise written by Vitruvius, a Roman architect, about the year 46 B.C. Vitruvius confirms the suggestion that perspective had an earlier origin, probably referring either to Euclid or to Pamphilus, a Greek painter of the fourth century B.C. who seems to have possessed great ability for accurate representational drawing. Pamphilus was responsible for the inclusion of drawing in the liberal arts education of early Greece. Another Greek, Polygnotus, of the same period as that of Pamphilus, has also given us good examples of the foreshortening of limbs in some of his figures.

In early Chinese painting, perspective was used intermittently, although, in the main, the idea of foreshortening is conspicuously absent in Oriental art. In the wall painting made in the ninth century (in the T'ang Dynasty) and reproduced on page 4 (as Pl. IV), the central figure is coincident with the points of convergence of edges forming the two centered rectangular forms; here is a metaphysical use of perspective. In a Sung Dynasty painting of some three hundred years later, also on page 4 (Pl. V), the buildings are rendered in an unforeshortened style—a form of isometric drawing (see p. 100). Note that the edges actually drawn parallel appear to *diverge* as they recede from the observer. This illusory phenomenon confirms the belief that the converse is true, that, in order to create an illusion of real visual experience on a two-dimensional surface, we must *converge* edges known to be parallel.

The Roman contribution to the science of perspective made in the days of Pompeii and Herculaneum is manifested in the murals and frescoes of those cities accidentally preserved by the eruption of Vesuvius in the first century. The type of perspective used in these murals is that which has a single point of convergence, similar to the device in the T'ang wall painting. After the period represented by the works of art unearthed at Pompeii, an archaic conceptual manner of drawing was resumed in the Occident, and for a long time the science of perspective was practically unused.

With the dawn of the Renaissance and the coming of the great Italian masters of the thirteenth century, perspective appeared once more. In its revived form, however, it was of much greater importance than in the past, for one of the new objectives in drawing and painting was realism. The rediscovery of perspective was made, in fact, largely as a result of deliberate and concentrated study by Filippo

Early Chinese Painting

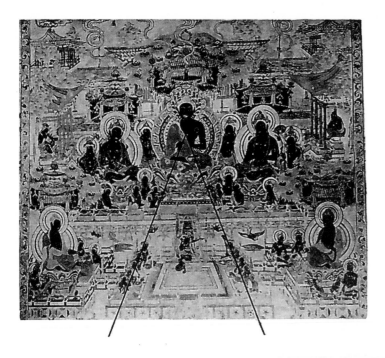

Plate IV. (left). T'ang Dynasty (early ninth century); detail from wall painting, *Amitābha Paradise*

Plate V (right). Sung Dynasty (twelfth century); section of painting, *Wên-chi's Captivity in Mongolia and Her Return to China*

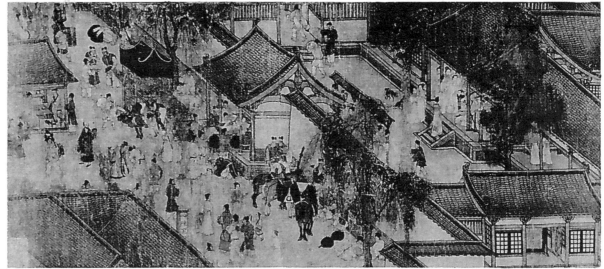

Brunelleschi. Such famous artists as Giotto, Masaccio, Uccello, Leonardo da Vinci, Raphael, and Michelangelo also practiced the reëstablished and almost perfected science. It is safe to say that the Greek and Roman treatises of classical times formed the foundation of the new geometrical perspective.

The more literal translation of visual experience in drawing and painting was, in part, at least, a reflection of the newly found interest of man in himself and in his physical environment. The human self-interest and realism characteristic of the Renaissance are especially striking in art when combined with the use of a traditional religious theme, as in Andrea Mantegna's painting, *The Dead Christ* (see Pl. VI). In this work Mantegna used a single vanishing point for both the figure and the supporting surface (see one-point perspective, pp. 84–88). The science of perspective was probably invoked here to show the nail holes in the soles of the feet, as well as in the hands, from a new point of view, and thereby achieve a dramatic effect. This painting further illustrates an emphasis upon terrestrialism, a dominant characteristic of the works of Renaissance artists.

The advance in knowledge of natural phenomena from the fifteenth century onward increased the enthusiasm for mimesis, or the imitation of things as they appear to the human eye. Naturalism remained in favor for nearly three centuries after

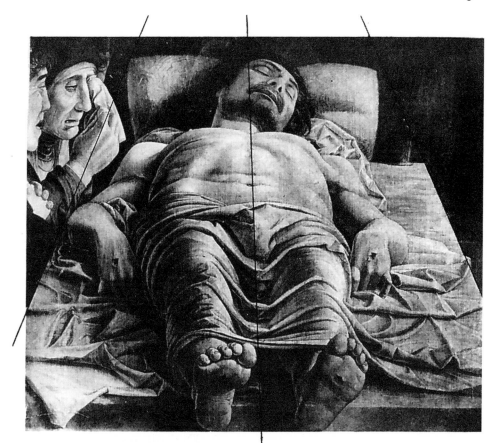

Plate VI. Andrea Mantegna, *The Dead Christ*

the Renaissance and still survives; its subject matter has included practically the entire gamut of visible phenomena. In the last quarter of the nineteenth century, however, an art of revolt came into being—revolt against naturalism, which was concerned with *appearances*. Outstanding among the new styles was Impressionism, the purpose of which was to record the *artist's reaction* to appearances. Impressionism regarded objects as aspects of light, and not precisely as objects of three dimensions. Temperament,

although important, was not the only cause of the revolt. An interest in exotic forms and in other material made known by archaeologists and art historians enlarged the scope of aesthetic comprehension. Not the least important causes of the change in artistic aims were the products of scientific and industrial development and research. The ever-widening use of photographic processes seems to have encouraged artists to emphasize artistic functions which differed from, or went far beyond, simple representation. We cannot be sure when the powerful influence of the camera actually became felt in the history of painting. What is authentic, however, is that about 1827 Nicéphore de Niepce produced a photographic picture which was unaffected by light; and that a little later, in 1839, Louis Jacques Mandé Daguerre produced photographic pictures of a landscape and other objects on a silver-plated copper plate, from which prints could be made; and that still later, about 1846, a process known as pictorial photography was under production, that is, photography as a means of personal artistic expression—an event which no doubt had a great influence upon the change in creative endeavor resulting in the movement known as French Impressionism and in other new "isms" of the period. Moreover, experimentation in color photography was being made as early as 1841.

Repercussions of the original revolt are still felt today, in the form of many new schools of thought in art. The leaders of some of these schools repudiate perspective as a prerequisite of drawing. They prefer the creation of formal order deriving from the mind to one deriving from natural appearances. In their view, drawing is specialized, and is part of a language called "imaginative creation"; it is a means by which they endeavor to convey emotions aroused by an object without objective reporting or literal transcription.

2. Definition of Perspective, Linear and Aerial

What is foreshortening? It is another name for perspective, a field of science as well as an integral part of art; specifically, the branch of geometry dealing with the rules of projection. Foreshortening, or perspective, is the recording on a flat surface of the correct oblique aspects of an object as they *appear* to the observer. Here the student will encounter his first difficulty; the observer's mind may at first obstinately refuse to accept the result as an actual linear shape, for he knows that the object is not linear, but three-dimensional. What the observer *knows* about an object and what he actually *sees* are not identical; yet, paradoxically, the more he knows about the object, the better he will be able to draw it in perspective.

a. Example of Linear Perspective

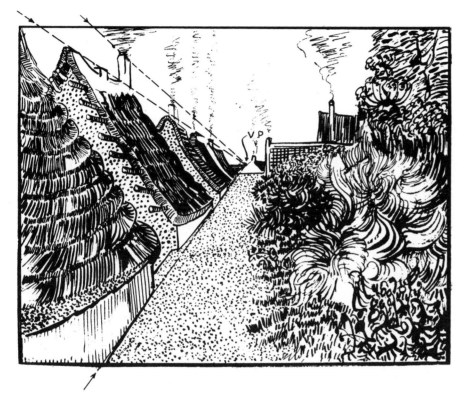

Plate VII. van Gogh; drawing, *A Street*

Linear perspective relates to projection and foreshortening, mainly by means of line alone, of the contours, internal and external, of an object. This is illustrated in the drawing by van Gogh, above.

The convergence of parallels and the diminution of objects in direct proportion to their distance from the observer produce the desired effect. The natural appearance of distant objects in particular and of the far distance in general is produced by a convergence of line and by a resulting diminution of size of objects as they recede into the picture. Notice that the appearance of the cottages on the left side of the street convinces us that they are of approximately equal dimensions, for the artist has recorded the correct oblique aspects (study the discussions of the theory of perspective on p. 71 and of the picture plane on pp. 72, 73; also, see measuring depths, p. 101).

b. Example of Aerial Perspective

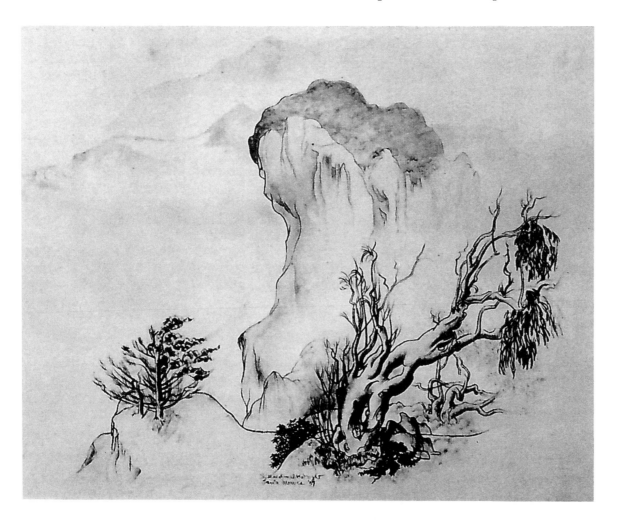

Fig. 1. S. Macdonald Wright;
pencil drawing, *Landscape*

The term "aerial perspective" is effectively defined pictorially in the accompanying drawing by S. Macdonald Wright (Fig. 1). It is expressed by the diminution in both the tone value and the relative size of objects as the scene recedes into the picture, or away from the picture plane. There are five main vertical planes here, representing foreground, middle distance, two far distances, and, finally, infinity. The effect of distance from the observer is achieved in part, also, by degrees of clarity of detail. Not only are the distant objects relatively smaller, but they are lesser in value intensity; this dual treatment produces an illusion of distance.

3. Common Errors in Perspective Drawing

As has been said above, optic mechanism and the science of perspective are inseparable. If the two conflict, however, the "sovereignty of the eye" is decisive. Your drawing must look right and "feel" right, in order to be accepted by the observer. Among the most common errors are:

> Poor selection of station point, causing (1) an uninteresting view of the object, or (2) undesired distortion, or a "forced" feeling

Vanishing points too close together, with consequent dipping of the nearest corner of the object, unacceptable to the observer

Distorted ellipses, unconvincing attempts to represent the roundness of objects

Disagreement of ellipses in relationship to eye level; causes seeming distortion

4. Equipment

Pencils used include both the black (1B–7B) and the hard (1H–9H) and may range from 7B, the softest and blackest, to 9H, the hardest and firmest. We use the B label, in the main, for freehand work, but in ruled or mechanical drawings both kinds may be used. The equipment most necessary for freehand drawing includes:

> Pencils—
> > Graphite, 1B–7B, Carbon, B–BBB
> > Charcoal or Conte
> Pocket pencil sharpener
> Sharp knife
> Very small box for pencil dust
> Sandpaper block
> Kneaded eraser

White eraser
White drawing pad, about 20" x 24"
Unprinted newsprint pad, 18" x 24"
Strathmore paper, 1 ply, 20" x 24"
Assorted papers, gray, white, etc., 20" x 24"
Lightweight drawing board
Portable, collapsible easel

Other desirable pieces of equipment, *not* to be used in freehand drawing, however, are:

> 18" ruler
> T-square
> Compass

Protractor
20°–60° triangle

The student should always remember that well-kept equipment means better presentation.

PART ONE

APPLICATION OF PERSPECTIVE PRINCIPLES

to

Freehand Drawing

I. ESSENTIALS OF REPRESENTATIONAL DRAWING

To achieve an intelligent, enterprising synthesis in drawing, the student must thoroughly understand perspective. Nevertheless, it is not enough merely to grasp the science of perspective intellectually; practical experience in the freehand aspects of perspective drawing is essential to a satisfying expression in this area of artistic endeavor.

The present manual deals only with the solid effect of objects in space. Less concrete, or abstract, drawing has been treated by many competent writers elsewhere, and the student of drawing who has a special interest in that type of creative work is counseled to investigate its possibilities.

It is a well-known but unfortunate truth that most people are pitifully unobserving. Indifference to the value of critical observation, coupled with the tendency to represent objects in terms of what is *known about* them rather than in terms of what is actually *observed*, forms one of the prime barriers to good representational drawing.

1. Definition of Representational Forms

The word "representational," for our purpose, means the truthful, graphic recording of the three-dimensional aspects of an object as it appears in light to an observer who is interested in developing his power of observation.

In order to draw well, one must possess a definite understanding of what he is about to state graphically, and also a well-developed skill in the use of the tools involved, a skill that will enable him to express what he wishes to say vigorously, delicately or elegantly, or with brevity—in any case, eloquently. Remember, then, that a good drawing, of the kind in which we are interested, requires more than skill in using certain equipment; it becomes, vitally, a matter of learning *really* to see, to observe. Educators tell us that, in all probability, more may be learned through the eyes than through the ears.

2. The Potential of the Pencil

The pencil, simple as it is, is one of the most responsive and most versatile of the artist's tools. In the hands of a competent artist it can produce the finished drawing, whether that be a sketch of the utmost brevity or a rendered drawing in full-scale dark and light modeling. Let us begin to understand this potentiality by learning forms of pencil expression.

The pencil may be trimmed in many ways; and, according to the special way in which it is trimmed, its point can produce a certain variety of lines. Thus, at will, the artist may have thin or thick lines, hard or soft and broken ones, firm, or semitransparent, or opaque, or textured lines—all of which are valid expressions of the pencil (see p. 15).

Use your ingenuity and imagination; discover for yourself the numerous other means of preparing pencil points.

Again, there are many ways of *holding* the pencil. One is likely to think of the pencil as nothing more than a *writing* instrument; on the contrary, the pencil held in different ways can produce lines, two-dimensional forms, or masses of varying natures. To explore the possibilities of the pencil is an absorbing experience.

a. Limbering-up Exercises

Before the student begins an actual drawing he should practice limbering-up exercises. Learn to draw long, straight lines not less than fifteen inches in various directions: left to right, right to left, vertical, horizontal, and oblique. Relax the wrist, and, holding your pencil almost parallel to the paper, place the side of the point on a starting place. Then look at another point relatively far from it, one with which you wish to connect it, and gently but firmly direct your pencil toward the more distant point. *Do not look at the pencil or the mark; look at the point of arrival.*

Next, try a similar exercise with long, curved lines, guiding the line through points marked off on the way. Always let your eye be a jump ahead of your pencil. Try using your intuitive processes, changing the direction part way along; after moving the pencil for some distance in one direction, reverse the curve, sometimes with a sharp, pointed break, sometimes with a curved change. Then repeat the whole series of exercises, practicing lines strictly parallel with one another—entirely freehand, of course.

Now develop the curved line into an ellipse of, say, three inches in length along its major axis (see discussion, p. 111). Shadow-draw first, that is, go through the motions without drawing; then, at an intuitive urge to draw, lower the pencil while moving, until it touches the paper lightly. Try again and again to complete the ellipse with an invisible join.

Fig. 2 (right). Pointed pencil; examples of use of the point, and also, of the use of the whole side of the lead

Fig. 4 (below). Chisel point; examples of use of corner, and of use of entire chisel edge (line begins and ends with a straight edge)

Fig. 3 (right). Truncated point; method of making a broad streak, with well-rounded beginning and ending

b. Examples of Eloquence of Pencil Lines by Some of the Masters

You will find plenty of illustrative material for comparative study in this field in your local library, museum, or art galleries; frequent and regular visits to these sources will bring rewards. Compare the styles of line by artists from various geographical areas.

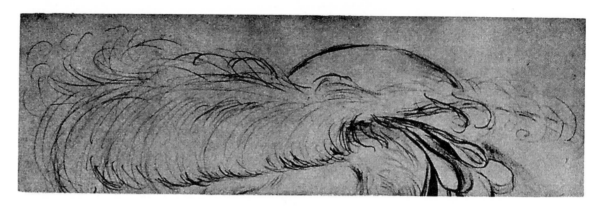

Plate VIII. Matisse; detail of pencil drawing, *White Plumes*

Plate IX (left). Degas; detail of pencil drawing, *Edouard Manet*

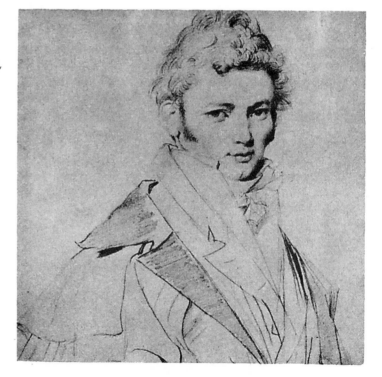

Plate X. Ingres; detail from pencil drawing, *The Guillon-Lethière Family*

The nude sketch below (Fig. 5), by S. Macdonald Wright, affords observation of an appropriate line for expressing a powerful figure, the tensions in which are psychologically felt by the observer. Compare this kind of line with the relaxed line of Ingres (see p. 16).

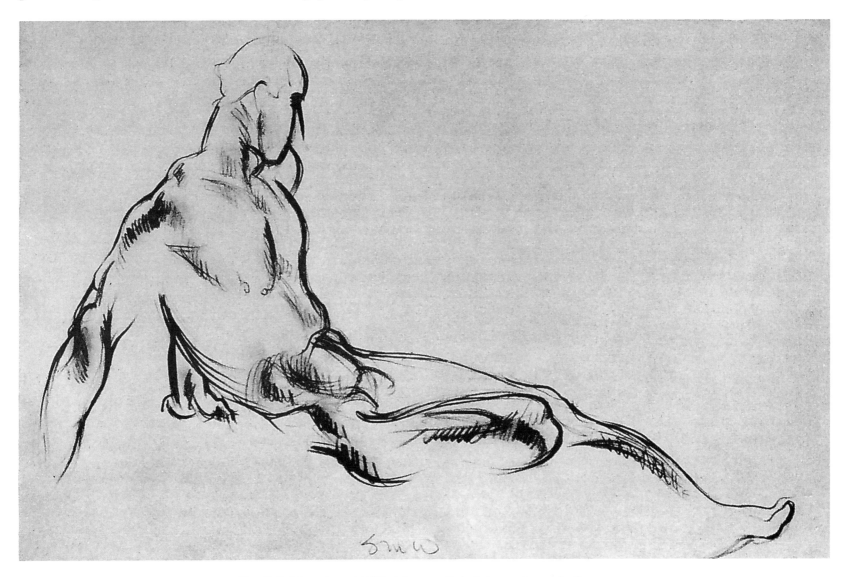

Fig. 5. S. Macdonald Wright; pencil sketch, male nude figure

II. THE FREEHAND SKETCH

1. Determination of View

As an aid to the beginner in his preparation for making a freehand sketch, the following procedure is suggested. You will find less and less necessity for some of the preliminaries as you progress; eventually you should be able to begin directly with the drawing itself.

a. Obtain a definite mental image of the object's contours and proportions.

b. Determine the size of the proposed sketch.

c. Decide upon what you consider to be the best view of the object, perhaps aesthetically, or perhaps purely descriptively, according to your purpose. The device known as the view finder, illustrated in the accompanying drawing (Fig. 6), will aid you in the selection of a desirable view. It is about the size of a post card over all, with a small, rectangular hole cut in the center. The relationship between the width and the height of the rectangular opening is to be the same as the relationship between the corresponding dimensions of the proposed sketch. The possible shapes range from a square to an extremely elongated rectangle, either vertical or horizontal. For an example of the horizontal elongated rectangle, see the sketch in the Makimono style on page 67. Hold the card parallel to your face at varying distances. Look through the hole with one eye, and turn the head

or walk around to get various views of the object. Try the opening both upright and as an oblong. Regard what you see as being the picture you wish to draw; relate it to the frame formed by the four sides of the aperture. Have confidence in your judgment, for the long record of the history of art—approximately eight thousand years—reveals the interesting fact that mankind has always had an innate sense of design and balance; he still has. In this particular, let your own intuitive sense for balance help you to select your viewpoint, or station point (see definition, p. 75).

Fig. 6. View finder

d. Locate the center of vision, the main vanishing points, and, consequently, the eye level (see explanation of terms, pp. 72–79, and list, p. 82). Notice where the eye level intersects the two vertical sides of the frame formed by your view finder. Transfer this information to your drawing paper. You should have made a very good start.

2. Relative Positions of Drawing Board and Student

The drawing surface should be placed in a position a little less than arm's length away, and should be tilted at an angle slightly away from you. Give yourself plenty of freedom of movement of both arm and torso. At frequent intervals step back from your drawing, observing it from a distance: you will quickly detect your own errors.

3. The Three Phases of Freehand Drawing

Freehand drawing may be learned in three phases:

First, after the view has been determined, establish, by drawing very lightly, the main contours of the object, found either by sight or by using the thumb-and-pencil measurement method demonstrated in Figure 7. For example: Contour edge A on the object corresponds to A marked off on the pencil in Figure 7. Note the difference in the apparent size of the object at this distance from the eye or from the object itself (see the illustration and the discussion of the picture plane, p. 72). Having marked off on your pencil the unit of measurement, turn your pencil to a horizontal position, keeping it parallel to your face (or to the picture plane) at all times. A true comparative measurement of one contour as related to that of any other, horizontal, vertical, or oblique, is thereby facilitated. Check the regular proportions of the object, the parts of an object or of separate objects, noting their spatial relationship to one another within the environment limited by the range of vision (see p. 76), as created and fixed by a single station point.

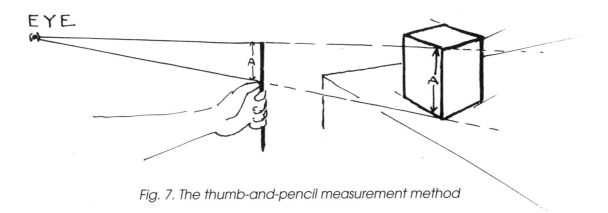

EYE

Fig. 7. The thumb-and-pencil measurement method

Secondly, sketch in most of the major details and some important minor ones. Your drawing is still in an understructure stage.

In the third or final stage you will find it expedient to use pencils with variously shaped points, described on page 15. Proceed by drawing all other major details and then completing the minor details, beginning with the more important ones and adding accents here and there where needed. All the while, concentrate on a center of interest, where your lines will be a little heavier, more distinct, more arresting. Be careful not to add too much dark too early. Remember, you can always add to a value or shade or an accent, but it may require an eraser to reduce that value, and the erasing will cause smudging and a "patched-up" look. Become aware of the background and of the relative importance of the several objects in the environment, or range of vision. You will often find that the contour or line direction of one object helps to bring out the contours of another (see p. 39). In this final stage, you may begin with the blocking of the darkest darks on lightest lights; this is optional.

Remember that, although expression in line drawing is a basic necessity, there are no lines in nature. Therefore, while you are experiencing the coordinated processes involved in creating a freehand line drawing, you should begin to think in terms of plane surfaces and of magnitudes and their contours, rather than in terms of lines alone.

Your drawing, if representational or naturalistic, must look right and feel right, in order to be accepted by the eye. Your understanding of perspective principles, gained from a study of the second part of this book, should enable you to draw convincingly an object or objects in your line of sight, and even an object which exists only in your mind. This understanding, when fully in your consciousness, will automatically direct your pencil point in the formation of a convincing, graphic statement of visual experience.

III. LINE DRAWING

1. Calligraphy and the Drawn Line

a. Examples from Manuscripts and Woodcuts

The sublime eloquence of line used in writings throughout the world, particularly in the writing of countries in the Near and Far East, is amply mirrored in the record of graphic achievement. This relationship cannot be ignored by the drawing student who seeks success. Some examples of these writings are presented below, for observation in the study of this aspect of drawing.

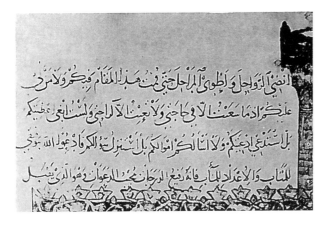

Plate XI (left). Yahya b. Mahmūd al-Wāsiti; detail from a manuscript of al-Harîrî's *Maqāmāt*

Plate XII. Late Medieval Period; detail of a woodcut, with Latin in German lettering

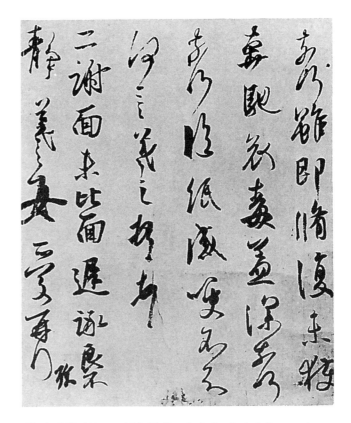

Plate XIII. Wang Hsi-Chih; detail of eighth-century copy of Chinese calligraphy of the fourth century

21

b. Calligraphy in Modern Abstract Drawing

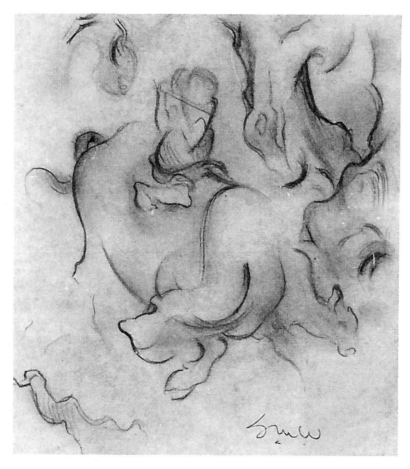

Fig. 8. S. Macdonald Wright, pencil drawing of an
Oriental theme

The character of the drawing of an Oriental theme (Fig. 8), by Professor S. Macdonald Wright, internationally known painter and art historian, demonstrates the way in which one artist effectively combines the related art of calligraphy with that of picturemaking.

2. Type Soloids and Simple Objects

In line drawing, line is your only vocabulary, your only means of saying something graphically. You may augment your vocabulary of line only by constantly acquiring a greater eloquence of line. Consider the virtues of good verbal expression: brevity with meaningfulness—saying what you wish to say simply, pointedly, and forthrightly. The camera, of necessity, records all details available to the lens; the artist, however, has a choice: according to his specific objective, he may select and emphasize the major characteristics of an object or group of objects and the environment, or he, too, may include all the details.

Learn to observe things more in the large, and at the same time more acutely, than you ever have before; in other words, try to perfect your sense of perception. Your constant striving to see things more fully will provide the experience necessary to determine more readily what the major attributes of a subject are, and to weigh the relative value of its parts and details.

Draw straight-line objects first, then curved objects, and finally, objects having both straight lines and curved lines. Also, on occasion, try completing your drawing in a self-specified time limit. A well-executed drawing of a simple, prosaic object is more gratifying to observer and artist alike than an unconvincing drawing of a more complex object, for the latter usually betrays the effort to achieve a goal beyond the capacity of the artist. Begin by drawing something relatively simple, in order that your effort may bring success, not failure. For example, go back to the six principal geometric soloids, the cube, the prism, the pyramid, the cylinder, the cone, and the sphere, for it is from these forms that all others derive, in more or less complexity (see Fig. 9, below). (For line depicting surface texture, see pp. 40, 42, 43.)

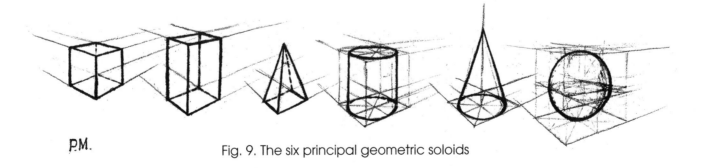

P.M.

Fig. 9. The six principal geometric soloids

a. Box Construction; Axis of Rotation

In Figures 10 and 11, vertical prisms have been sketched in first; they become dependable scaffolding on which to draw chairs or other objects having a rectangular prism as the primary form. For the beginner, if the prism is drawn convincingly as an object in space, its derivative may be enclosed and the object in the drawing will appear more true to actuality than it will if sketched directly. Experience in drawing will bring about less and less need for such beginners' "props" (see also box construction, p. 93).

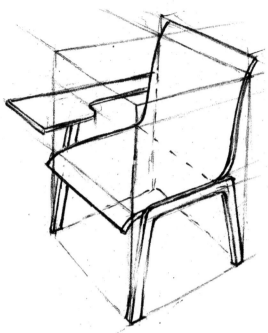

Fig. 10 (above). Box construction

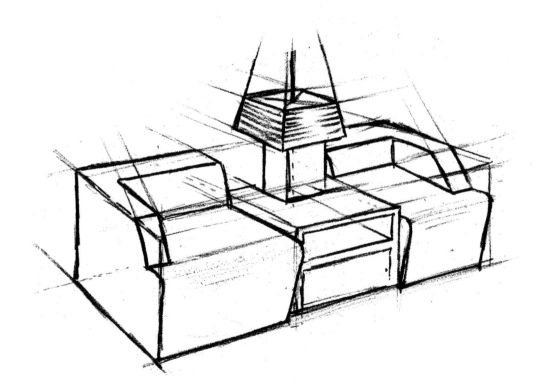

Fig. 11 (left). Axis of rotation and box construction. Note the freehand use of the preliminary construction of the axis of rotation in the drawing of the table lamp

b. Proportions and Plane Direction; Composite Use of Type Soloids

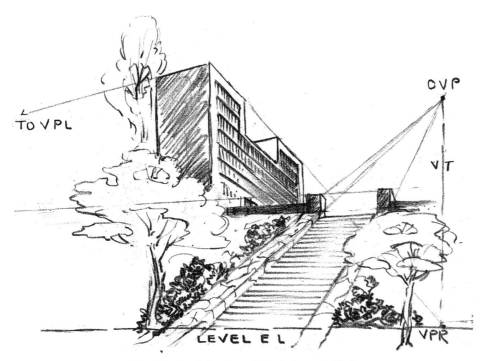

Fig. 12. Architectural sketch, uphill view

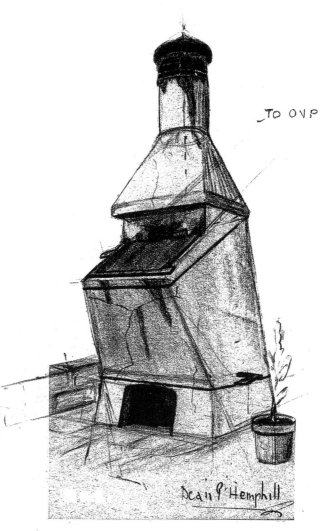

Fig. 13. Pencil drawing, incinerator

The architectural sketch above (Fig. 12) exemplifies an interest in measuring depths, both in level planes and in inclined planes—in this instance, the steps. The result, obtained only through practice and understanding: the *proportions and plane direction* are acceptable to the eye.

The student drawing at the right (Fig. 13), made for exercise purposes, is an example of the *good use of composite form*—cylinder, cone, prism, and pyramid, plus the inclined plane of the lid.

These type soloids constitute the irreducible and clearest terms expressing the facts of mass. Study as great a variety as you can. The concept of mass will help you to become conscious of structure, internal and external, and also of the fact that in most of the regular forms there is a central axis of revolution. This axis is important, for upon it one builds the mass.

The object presented in Figure 14 is a simple example of a *combination of type soloids: rectangular and curved forms.* Look about you for other objects of this kind.

You will see faint evidence of perspective guide lines in this drawing; they may not vanish precisely at a vanishing point, or precisely on the eye level, but they are reasonable enough for visual acceptance. In a drawing of the representational kind we must bear in mind the "sovereignty of the eye."

The forms of architectural and utilitarian objects all afford excellent subject matter for freehand perspective drawing. Practice sketching industrial and domestic buildings, churches, and billboards, and also the more familiar indoor objects, such as furniture and household utensils.

One may master the ways of properly representing the relative proportions of an object if he remembers the exercise in measuring depths (see p. 101). The beginner may wish to use the thumb-and-pencil measuring device explained on page 19, first selecting a known unit of mea-surement. For example, in the drawing of a chair, the unit of measurement governing the entire construction could be the height of the seat from the floor. Likewise, when drawing steps, the height of the *nearest* step (approximately six inches) may be taken as a unit for the series.

Fig. 14. Pencil drawing, bowl with rectangular forms and curved forms

In this perspective sketch of twin campaniles (Fig. 15), one feels the whole form of a tall, rectangular prism, with a central part removed. This logically causes the edges of the tops of the towers on the right face of the building to fall on a continuous vanishing line. The top edges of the other faces will converge toward a joint vanishing point, but *not* on a continuous vanishing line. The apex of the triangular pediment falls on a line in the perspective center of the rectangular void.

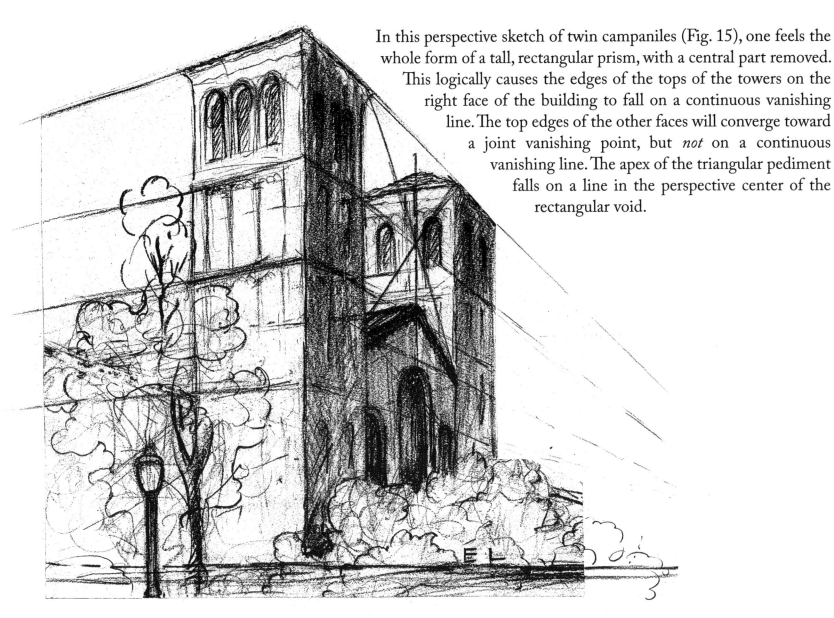

Fig. 15. Pencil sketch, twin campaniles, first view

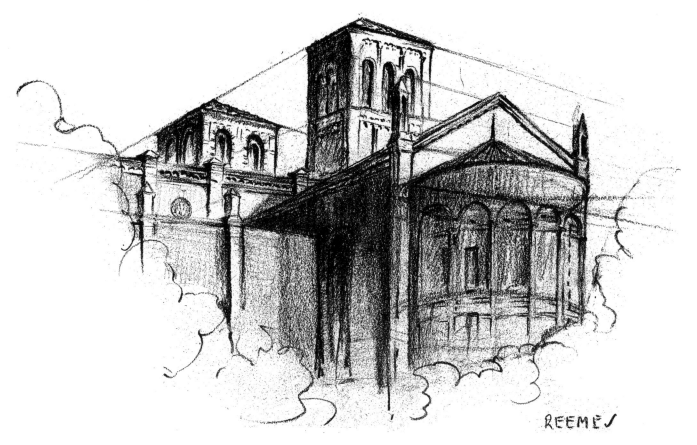

Fig. 16. Pencil sketch, twin campaniles, second view

This sketch of another view of the building pictured on the preceding page provides evidence that the architect utilized a variety of type forms to produce an integration: pyramid, cone, cylinders, vertical and horizontal (the latter in the arches), as well as rectangular prisms. Only a part of the cylindrical form at the right appears, the whole having been cut virtually in half. This is a detail to be practiced separately; in conjunction with the exercise, try sketching a half-round table against a wall.

3. Round and Curved Objects

a. Suggested Exercises

Do plenty of exercises from life in round and oval objects, either forms found in nature or the products of manmade design. Set up such things as vases, fruits, vegetables, and seed pods. This subject matter will provide excellent material for practice in the drawing of the ellipse, or foreshortened circle.

Try drawing an object at different eye levels. Put it sometimes on the table, sometimes on the floor. Try it on a glass-topped table above your eye level. Also, as in your previous experiments in drawing objects having straight edges, try drawing it well foreshortened by placing it on its side, turned in a direction away from you.

Note that in the accompanying reproduction of a part of Pieter Brueghel's painting, *A Peasant Wedding* (Pl. XIV), the major axes of all the horizontal elliptical forms of objects resting on level planes are also horizontal, and therefore parallel to the bottom of the picture frame.

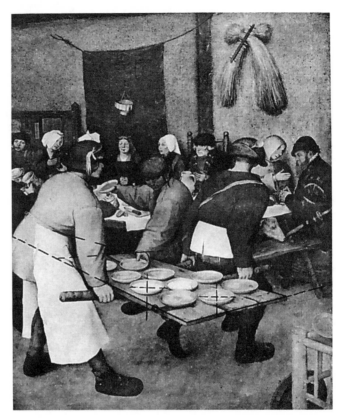

Plate XIV. Pieter Brueghel the Elder; detail of painting, *A Peasant Wedding*

Fig. 17. Sketch, hemispherical bowl, well below eye level

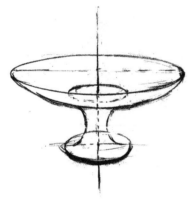

Fig. 18 (above). Sketch, shallow bowl, somewhat below eye level

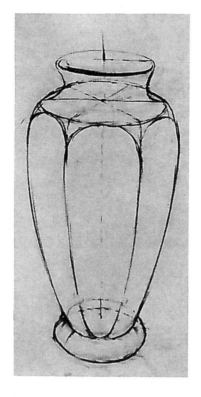

Fig. 19. Drawing of vase, showing part of axis construction

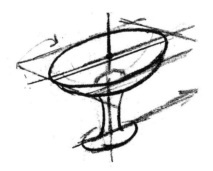

Fig. 20 (left). Sketch of compote, showing construction of perspective view of noncircular curve

Get experience in drawing forms that are composites of regular curved soloids, such as cylinders, cones (upright or inverted), and spheres. Remember to adjust the roundness of ellipses in relationship to the eye level (see p. 113).

Several varieties of composite forms and various relationships to the eye level are illustrated in the accompanying sketches. We know that the object in each of the upper three sketches (Figs. 17–19) is round, because the horizontal diameter of the perspectively drawn circle meets the axis of rotation of the object at an angle of 90 degrees.

In drawing the compote pictured in Figure 20, however, the artist implies that the object is not actually round, but is an oval; for, normally, we see a round object as an ellipse the major axis of which is horizontal, and therefore at right angles to the axis of rotation (compare especially with Fig. 19).

Fruits, vegetables, blossoms, and seed pods provide endless practice matter for drawing visually acceptable elliptical forms with assurance. In order to develop this skill it is necessary to have a thorough working knowledge of the constructional relationship between the ellipse and the axis of rotation of the object.

Study this principle closely. It is one of the weak points in student drawing. Do much practicing in this area. Acquire the ability to present the simple horizontal ellipse and become aware of the difficulties of the more complex problem of representing ellipses on vertical planes in two-point perspective (that is, on planes not at right angles to the picture plane). The rules governing this more difficult problem will be understood more clearly as you proceed.

Fig. 21. Practice drawings in elliptical representation of round forms found in plant life

b. Internal Structural Framework of Natural Forms

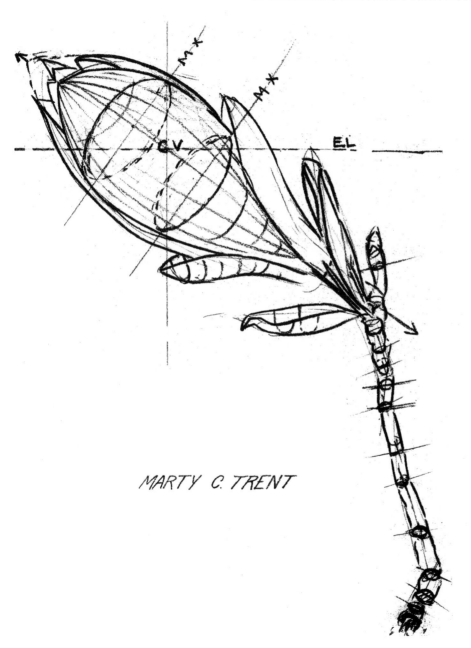

MARTY C. TRENT

Try sketching in perspective the internal structural framework of natural forms, as an exercise, using geometric forms as the substructure. Do not model or shade in this exercise; draw only the logical geometric lines.

In the accompanying example (Fig. 22) one sees the cylinder, the cone, and abstract concave and convex forms, all of which are sketched as if made of wire framework. Compare this with the modeled sketch of the same object on page 52.

Fig. 22. A bud and its supporting twig; an example of the structural relationship between the axis of rotation and circular forms seen as ellipses

c. Foreshortened Position of Opposite Features

When drawing an object with features opposite each other on perimeters, or "ellipses," be sure to turn the object so that those features will be viewed in foreshortened positions.

Do not place the object with such features directly at the left and right, as was done for the sketch of the sugar bowl in the lower right-hand corner of the accompanying illustration (Fig. 23).

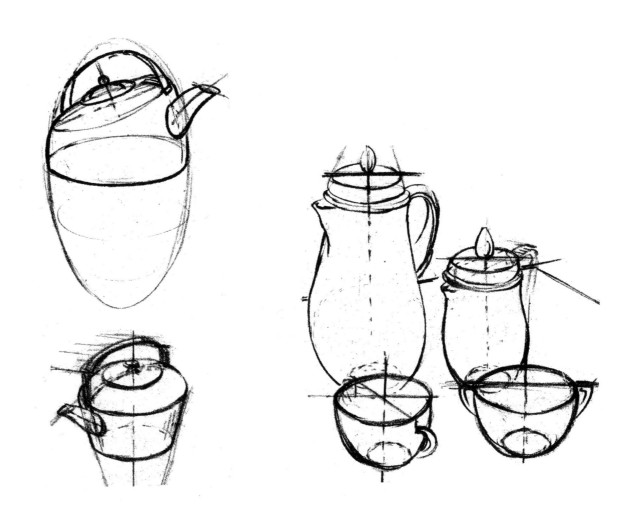

Fig. 23. An illustration of the contrast between good and poor views of objects having opposite features

d. Tangency of Internal Ellipses to Sides; Lengthening of Minor Axis of Ellipse

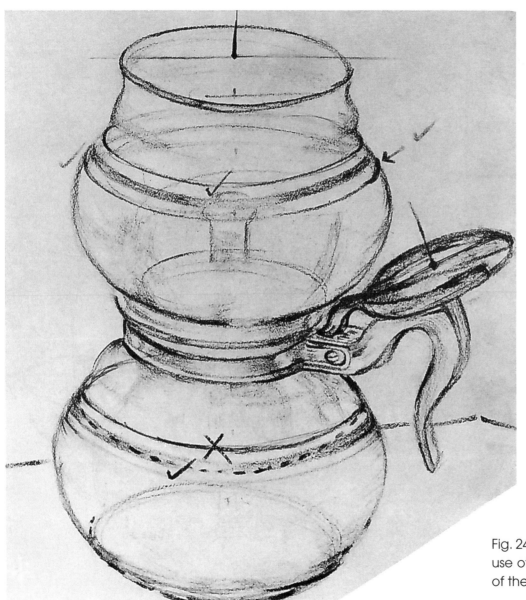

Be sure that every internal ellipse forms a *tangent* to the sides of the object. Intersecting edges are unacceptable to the eye.

Remember also the principle regarding the lengthening of the minor axis as an elliptical form descends below the eye level (see Fig. 158). In the sketch at the left (Fig. 24), in the bottom section of the object, ellipse X should be lower, approximately where the broken line marked ✓ has been drawn.

Fig. 24. Sketch of a glass coffee-maker, illustrating the use of internal ellipses and the comparative lengths of their minor axes

e. Beginning Sketching in Architecture

Architecture lends itself very suitably for our purpose. Take up a station point that affords an interesting view. Use your view finder and relate the contours of the object pleasingly to the four sides of the frame. Use "shadow drawing" technique. Do not try to block in the final lines at the onset. Draw lightly at first and "feel" your perspective way through the structure of the object.

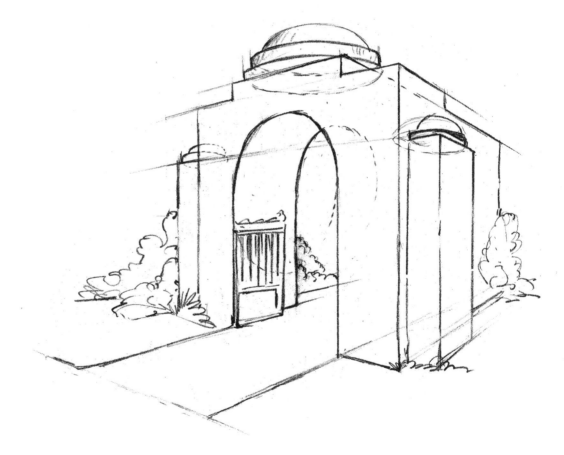

Fig. 25. Architectural sketch of ornamental gateway

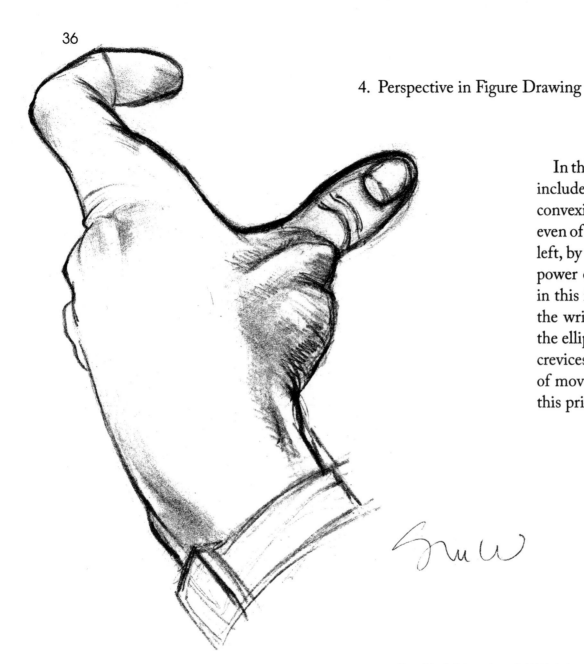

4. Perspective in Figure Drawing

In thinking of round or curved figures, one should include the human figure. It is a complexity of convexities and concavities, of cylinders and cones, even of spheres and hemispheres. The drawing at the left, by S. Macdonald Wright, is an example of the power of the elliptical line to enhance movement; in this instance, the thrust of the entire hand from the wrist to the fingertip is forcefully accented by the ellipses of the wrist-watch strap and of the skin crevices of the finger joints. Result: a clear indication of movement *away* from the picture plane. (Study this principle on p. 119.)

Fig. 26. S. Macdonald Wright; pencil sketch, foreshortened view of a hand

In the drawing at the right, the principle of cylindrical direction (see p. 119) also applies, and this was recognized by the artist, Professor S. Macdonald Wright.

Here, the lower part of the torso recedes from the picture plane, and the fact is recorded and enhanced by means of elliptical structural lines of the right breast, the position of the nipple, and the succession of curved lines immediately below the breast. Similarly, the lower part of the woman's right thigh moves away from the picture plane. The lower part of her left thigh, however, moves toward that plane, and the psychological effect of the whole figure is one of movement forward, *toward* the observer.

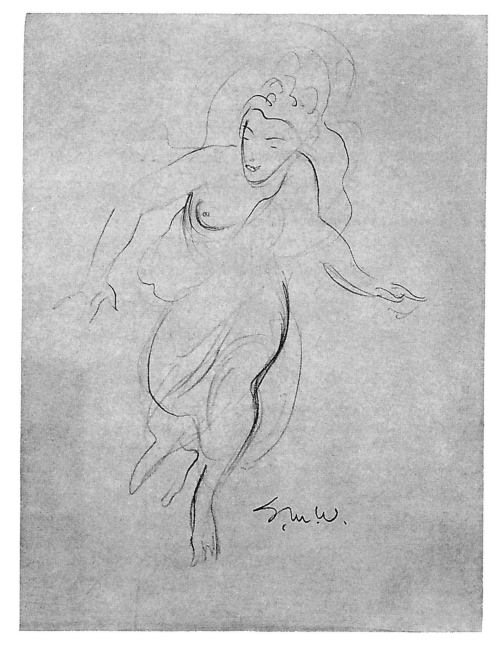

Fig. 27. S. Macdonald Wright; line drawing in pencil, female figure running

IV. RELIEF DRAWING, OR DRAWING IN LIGHT AND SHADE

1. Comparison, Line and Relief Drawing

There are many occasions on which line drawing is indicated as desirable. Often, a well-executed line drawing or sketch is acceptable and fully meets the need of the patron—a fact borne out by the quality of many etchings, wood engravings, and silverpoint and drypoint drawings, as well as by that of many pencil drawings and lithographs. On the other hand, drawing by line alone, or delineation, is an incomplete graphic statement of nature, for in nature there are no lines, but only edges of surfaces or planes. The action of the light upon the surface produces an effect of gradation of light and shade (values) by means of a reflecting process.

When you feel satisfied with your progress, and when your line drawings are convincing and reflect a knowledge of the internal structure, you may begin to use shading or modeling.

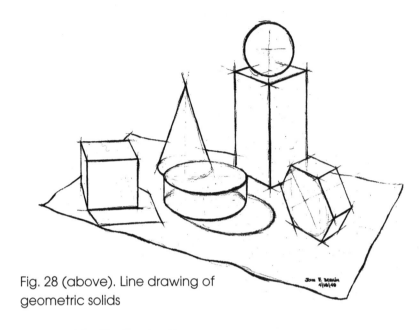

Fig. 28 (above). Line drawing of geometric solids

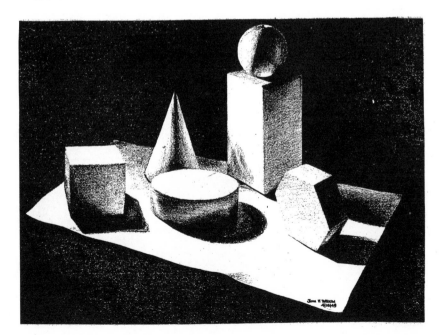

Fig. 29 (right). Relief drawing of geometric solids

38

By the use of the modeling or relief technique—that is, by making a relatively complete graphic recording of the external physical aspects of an object in gradations of light and shade—the artist is able to give the observer a more vivid realization of the volume and form of the object than could otherwise be imparted. Truthful and consistent recording of values is as necessary to a convincing graphic statement as is a proper observance of perspective laws pertaining to position and relative size.

Actually, the light and shade on an object are the effects of light reflected by its surfaces. We may therefore expect gradations of value in accordance with the lighting conditions, the nature of the receiving surfaces, and the nature of near-by objects.

Seurat's *La Baignade* (Pl. XV) is an excellent example of form without line. An Impressionistic painter, Seurat records objects as aspects of light, and he clearly states the nonexistence of line *per se* in nature.

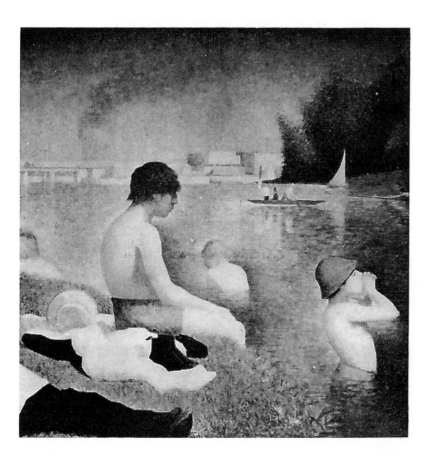

Plate XV (left). Georges Seurat; detail of painting, *La Baignade*

2. The Tonal Scale

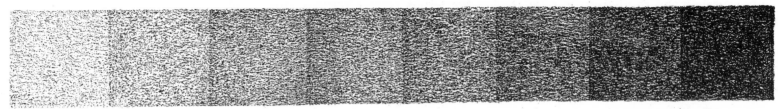

Fig. 30. Simple tonal scale, in compartments

Try using various textures in making tonal scales, remembering that the edges of each compartment reflect internal texture (see strokes, p. 42).

Fig. 31. Tonal scale with texture, in compartments P. O'C.

Next, try a tonal exercise without divisions, a slur scale (see Fig. 32). Now try the scales in reverse. Keep your pencil movement within certain limits, or faintly sketched guide lines forming the enclosure.

Fig. 32. Tonal slur scales

3. Practice Strokes in Pencil; Suggestions for Textures and Modeling

Use your ingenuity in modeling. You will discover that you can create innumerable techniques and patterns. Observe natural forms: botanical, geological, horticultural, agricultural. Seek out the qualities that abound in nature; you will find it a stimulating experience in the development of your ability to represent textures for modeling processes, as well as in your personal appreciation of the quality of various textures. For example, the sketch of the wood grain, on page 42 (Fig. 33), reflects the quality of a "line" found in natural forms; actually, the lines are strips of color.

Form can be either crisply or hazily indicated, and by many techniques—crosshatchings, smears, stipples, wiggles, hooks, etc., an almost endless variety of strokes producible with that versatile tool, the pencil. Enjoy yourself by spending some time in this fascinating and encouraging experience. Study the suggestions on page 42, in Figure 34; in the tablets, bottom right, notice that *white* lines and white smears can be created with your *black* pencil!

Imagine the difference in contour treatment of a swansdown powder puff and an apple, for example, and draw your findings. In the detail drawing by Ingres, on page 16 (Pl. X), note the difference between the hair line and the coat line; and in the detail drawing by Matisse, on the same page (Pl. VIII), observe the difference between the feather line and the line of the hat crown.

Pencil dust gradations: Conte, graphite 4B. Another method of modeling is the use of pencil dust. To make pencil dust, shake into tiny boxes the pencil dust from sandpaper used when sharpening pencils: 3B or 4B graphite, carbon, or Conte. Keep a separate box for each kind of pencil dust; do not mix.

The gradations seen on the drawing of a sphere, on page 46 (Fig. 45), were achieved by dipping a number 2 or number 3 sable brush into a box of pencil powder and applying it with small, circular strokes. Larger areas require a relatively larger brush.

To the beginner, however, another possible instrument is available: Cut a small piece of fine sponge to a sharp point; insert it into a charcoal-stick holder, and use the pointed end for dipping into and applying the pencil dust.

This style of modeling can also be effected with fairly pleasing results by careful handling of a pencil, with the side of its point-cone held flatly against the paper (see Fig. 2, p. 15), and applied in small, circular movements.

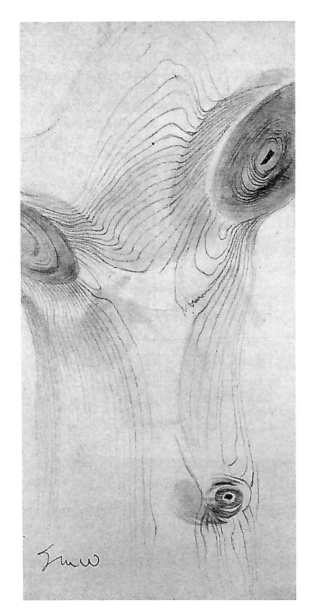

Fig. 33. S. Macdonald Wright; pencil sketch, texture of wood grain

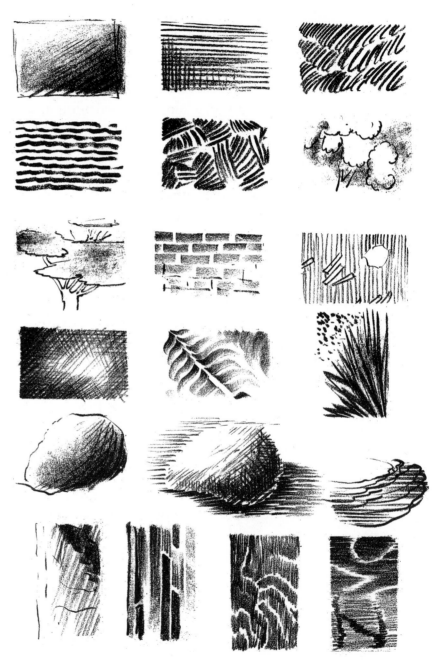

Fig. 34. Pencil strokes for various textures

4. Form without Line

a. Comparison between Forms with Line and Forms without Line

Modeling can be achieved in a score of ways and may be as highly individual as line itself (see pp. 40, 41). The ultimate in modeling could lead to a total absence of line, the form being achieved through tonal value alone.

Fig. 35 (above). Cube: form without line

Fig. 36. Cube: form with line

Fig. 37. Abstract architectural design: form without line

P.O'C.

In the cube directly above, Figure 36, the enclosing line is superfluous. A cube without line (Fig. 35) is more natural. In scientific illustration, however, and in some styles of surface decoration, forms are sometimes outlined (see Fig. 38).

R.K.

Fig. 38. Shading and outline techniques combined

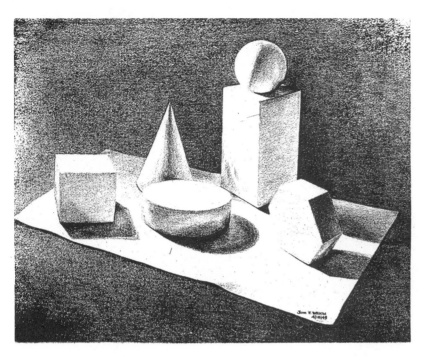

Fig. 39. Type form solids, drawn almost without line

b. Use of Models of Type Forms; Experience with Tonal Scales, Textures, Gradation of Values

In proceeding with the use of light and shade, again go back to the six type forms.

Actual models can be made quickly and cheaply from any ordinary, light-colored modeling clay. For our purpose, they may be just a few inches high. For lighting, a tilted table lamp is satisfactory, but a spotlight is preferable.

Fig. 40. Rectangular prisms and their ground plane, under direct light

Draw with a view to creating form more directly by tone than by line. *Experience with the tonal scale* and with various textures may now be brought into full play.

Notice the *gradation of value* on the right-hand surfaces in Figure 40. This is the effect of a reflected light coming from the ground on which the objects rest; the ground is exposed to the same light source as that to which the rectangular prisms are exposed.

5. Type Form Evolutions

a. Suggestions

The two familiar objects illustrated in Figures 41 and 42 suggest other possibilities beginning with type forms. Look about you; try some structural diagnoses of objects at hand. When you are ready to sketch, decide whether you can achieve better results by beginning with the darkest darks or with the lightest lights; choose your own method.

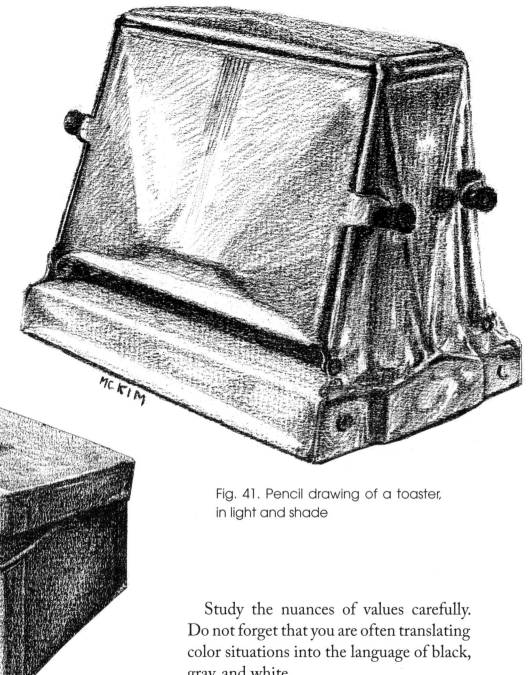

Fig. 41. Pencil drawing of a toaster, in light and shade

Fig. 42. Pencil drawing of a box, in light and shade

Study the nuances of values carefully. Do not forget that you are often translating color situations into the language of black, gray, and white.

b. Convex and Concave Forms

There are three distinct areas under single, direct light. As marked in the illustration below, Figure 45, these are: A, the direct light area; B, the darkest area, known as "the core"; and C, the reflected light area. C is the area on the under side, or dark side, of the object, partly illuminated by light rays reflected from the ground surface; C is darker than A, since the reflected light is much less intense than the direct light.

These rules apply to any curved surface under direct light conditions, and will be present in lesser degree under strong diffused light. Notice them in the multiflexed, oblique-horizontal, and vertical cylindrical forms in Figures 43, 44, and 46.

If a sphere rests upon a level surface, such as a table (see Fig. 45), the direct light rays striking that plane are reflected on the under surface of the sphere—hence the term, "reflected light area."

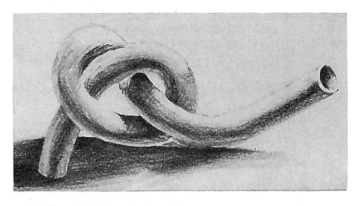

Fig. 43 (above). Multi-flexed cylindrical form

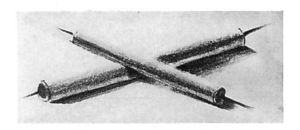

Fig. 44 (above). Oblique-horizontal cylindrical form

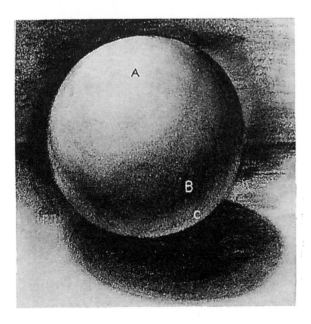

Fig. 45 (left). Light areas in sphere drawing: A = direct light area; B = core; C = reflected light area, accentuated by contrast and by the imminence of the cast shadow

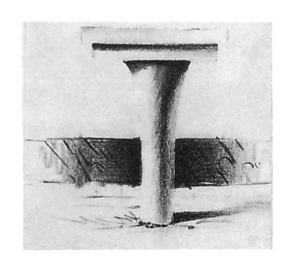

Fig. 46 (right). Vertical cylindrical form

1) Regular and Irregular Curvature

Seek confirmation of the value principles of the direct light area, the core, and the reflected light area under various lighting conditions—bright sunlight, artificial light, and the light of dull days. Find evidence in drawings and photographs. For actual drawing experience, set up a suitable object on a base of light value and tilt a table lamp or other direct light so that the desired effect is achieved.

Study and practice the exercise at the left (Fig. 47), in convex and concave forms exposed to the same light source. Notice how reverse situations obtain in concave forms, when the positions of dark-light areas are reversed. The same rule pertains to any curved surface, whether it be of regular or of irregular curvature. Study the scientific drawing of the triturus embryo (Fig. 48).

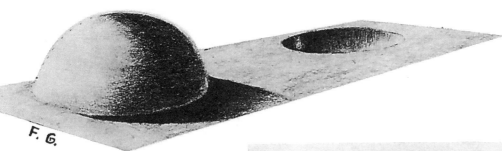

Fig. 47 (above). Reversed regular convex and concave forms under the same light

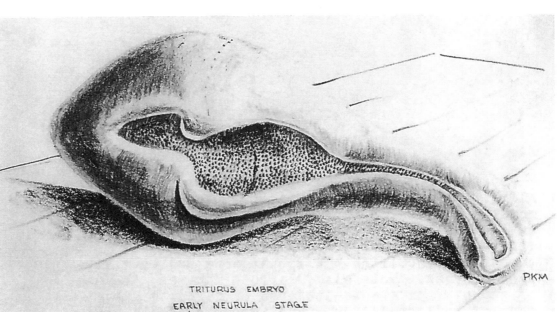

TRITURUS EMBRYO
EARLY NEURULA STAGE

Fig. 48 (right). Scientific drawing; example of irregular convexity and concavity

2) Curvature and Perspective in Drawing the Human Form

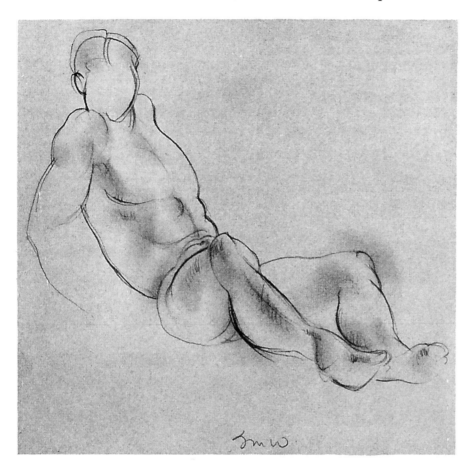

Fig. 49. S. Macdonald Wright; sketch of male figure

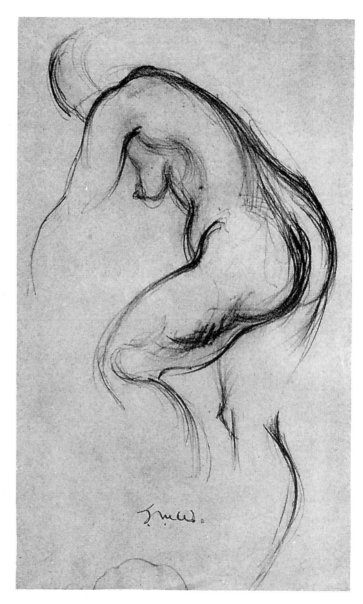

Fig. 50. S. Macdonald Wright;
sketch of female figure

These two quick sketches by Professor S. Macdonald Wright provide interesting studies in delicate modeling and versatile line, and also in foreshortening, particularly in the right thigh of the male figure. The foreshortening has been achieved by a carefully calculated but spontaneous use of elliptical curves. Note also, in both figures, the use of three value areas—the area of direct light, that of reflected light, and the core (see p. 46).

Plate XVI. George James Cox; wood engraving (actual size), *Mermaid*

3) Curvature and Perspective in Light and Shade in the Human Form

The two accompanying reproductions, by George James Cox, R.C.A., document conclusively the exquisite line and texture created by the wood engraver.

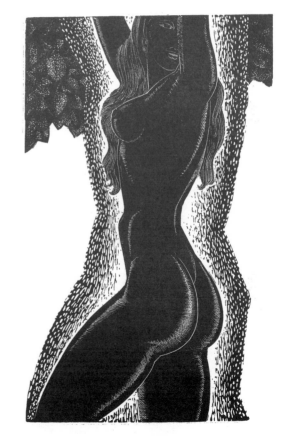

Plate XVII. George James Cox; wood engraving (actual size), *No More Dryads*

George James Cox was one of the foremost contemporary artists in this field. Spiritually, his talent as a sculptor is "felt" in linear forms somewhat as S. Macdonald Wright's understanding of Oriental calligraphy is "felt" in his drawing.

Compare the rhythmic, dynamic swirl of the *Mermaid* engraving with the upward-flowing movement of *No More Dryads*. Partial outlining of the nude forms is used; auxiliary forms are almost completely dependent upon texture for delineation.

Of great importance is the invocation, throughout, of the principles of the core, the direct light area, and the reflected light area, in representing curved surfaces. However, the three-dimensional perspective plastic character is psychological, by reason of the treatment of over-all values, or chiaroscuro.

c. Derivatives of the Cylinder

The object in Figure 51 has sixteen protruding features in its complete circumference. Try to get these in the right places (see the discussion of the principle involved, p. 120).

Fig. 51 (above). Pencil drawing of tray with opposite features and design in relief

The table in Figure 52 has four legs, each one opposite another. Use the same principle (see p. 120) in placing them.

Fig. 52 (left). Pencil drawing of circular table

d. Derivatives of the Cone

A high eye level often affords a dramatic view (see Fig. 53). Observe the well-selected positions of the handle and spout, known to be at right angles to each other; also, the excellent treatment of light effects.

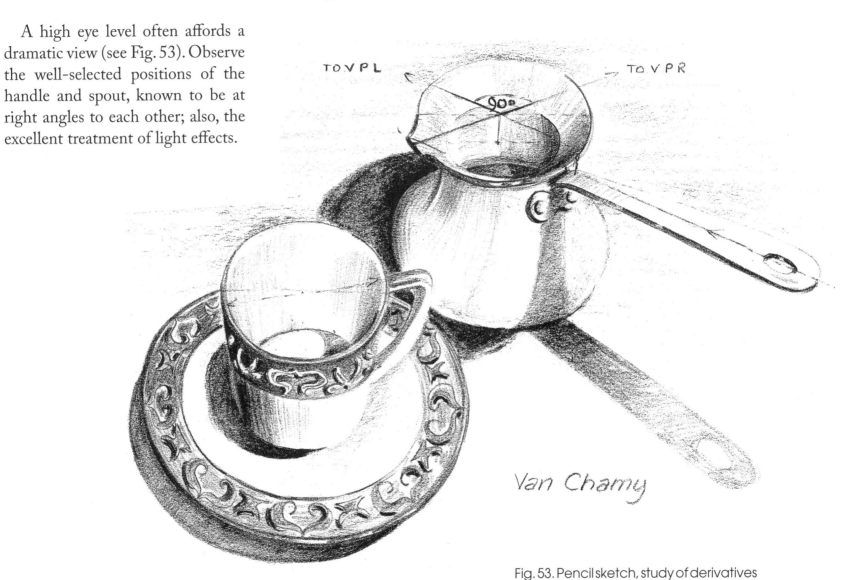

Fig. 53. Pencil sketch, study of derivatives of the cone, under direct light

6. Scientific Illustration, Modeling Techniques

a. Student Drawings

The five drawings appearing as Figures 54 through 58 are the work of students of scientific illustration. Many surface textures are represented, and contour edges are well considered. The students have kept in mind their convictions concerning perspective and its value to their objectives.

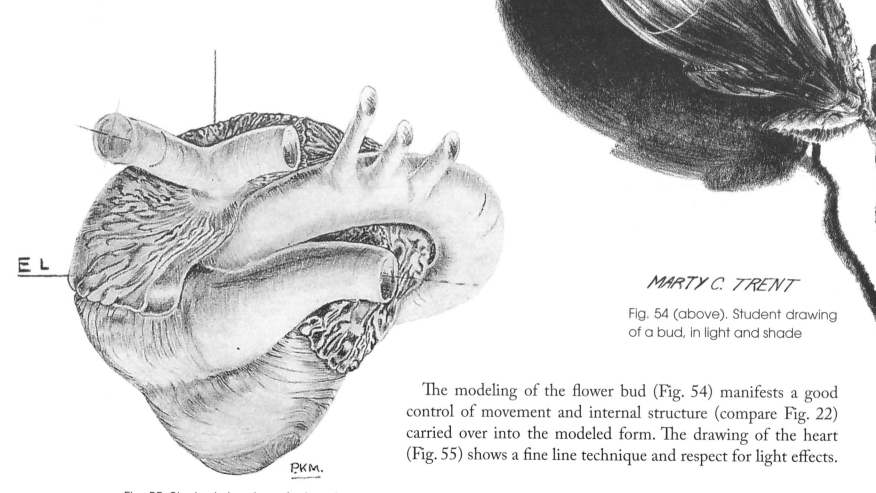

MARTY C. TRENT

Fig. 54 (above). Student drawing of a bud, in light and shade

Fig. 55. Student drawing of a heart

The modeling of the flower bud (Fig. 54) manifests a good control of movement and internal structure (compare Fig. 22) carried over into the modeled form. The drawing of the heart (Fig. 55) shows a fine line technique and respect for light effects.

The sea horse (Fig. 56), with its compartmental outer covering and its tiny, hornlike protuberances, is well modeled in stipple technique. A subtle light effect is achieved.

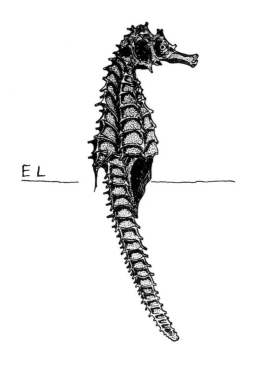

E L

The shell (Fig. 57) is modeled with an adequate crispness for a sharp-edged, hard material—a combination of fine line and smear.

FRED GUIOL

Fig. 56 (above). Drawing of a sea horse, in pen and ink

M.S.

Fig. 57. Pencil drawing of a shell

M·T.

Fig. 58. Drawing in pen and ink, orange

The coarse stipple technique in Figure 58 is carried faithfully to the outer contours, giving the spherical form a distinct quality of citrus peel. Note that the texture almost disappears in the direct light area (see the discussion of sphere drawing, p. 46).

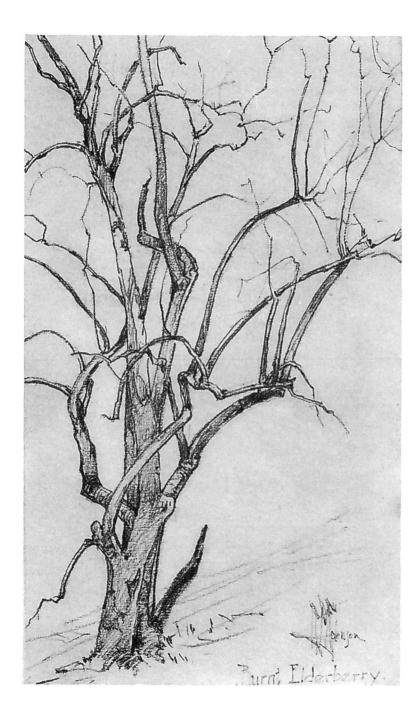

b. Professional Scientific Illustration

The next nine drawings (Figs. 59 through 67) are the work of the late eminent scientist, Dr. Arthur Monrad Johnson, Professor of Botany at the University of California, Los Angeles.

Scrutinize them carefully, and *discover for yourself* just how essential a thorough knowledge of perspective principles is to adequacy in graphic scientific description. You will perceive the manner in which the scientist draws, or prefers the scientific illustrator to draw, the forms relevant to his special field of research.

These drawings, like many others in this book, express a well-developed power of observation and an ability to present an object or group of objects graphically. Note the assurance manifested by the calculated yet free manner of drawing regular or irregular curved index lines within forms of a part within the whole; the movement of mass away from or toward the picture plane, and to the left or right of the observer's line of sight; the use of light and shade principles; and, finally, the convincing manner in which *one person* may demonstrate his versatility in a broad range of subject matter.

Fig. 59 (left). Arthur Monrad Johnson; pencil sketch, *Burnt Elderberry*

Geological studies require an exactness of description. The perspective of the cylinder is obviously employed in the drawing at the right. Also, you will recognize Dr. Johnson's use of concave and convex modeling.

Fig. 60 (right). Arthur Monrad Johnson; pencil drawing, *In Whitewater Wash— Sculpturing in the Arroyo*

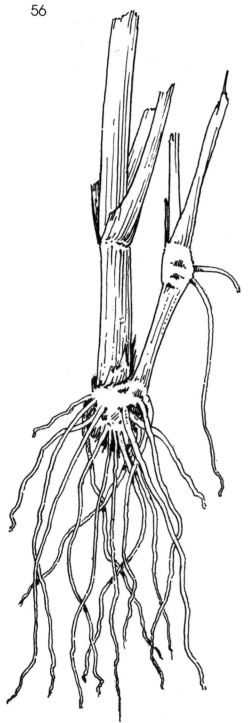

Fig. 61 (left). Arthur Monrad Johnson; pen-and-ink drawing, barnyard grass

Fig. 62 (right). Arthur Monrad Johnson; pen-and-ink drawing, *Asparagus Sprengeri*

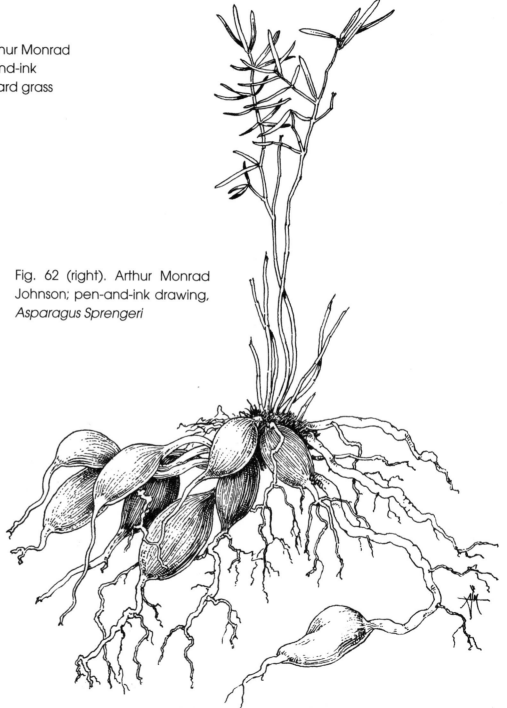

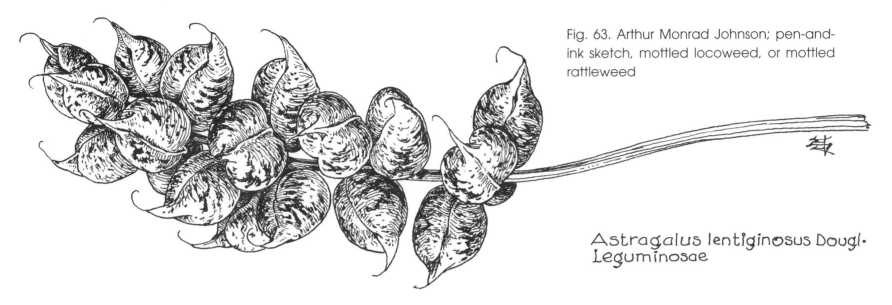

Fig. 63. Arthur Monrad Johnson; pen-and-ink sketch, mottled locoweed, or mottled rattleweed

Astragalus lentiginosus Dougl. Leguminosae

Fig. 64 (below). Arthur Monrad Johnson; pen-and-ink drawings of a strawberry

Fig. 65 (below). Arthur Monrad Johnson; pen-and-ink drawings of the euphorbia

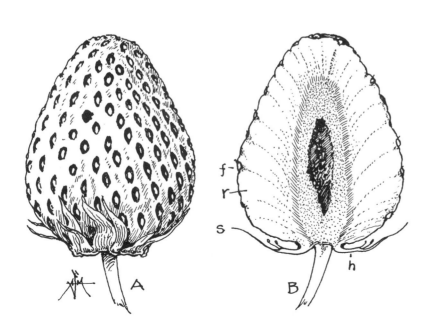

EUPHORBIA

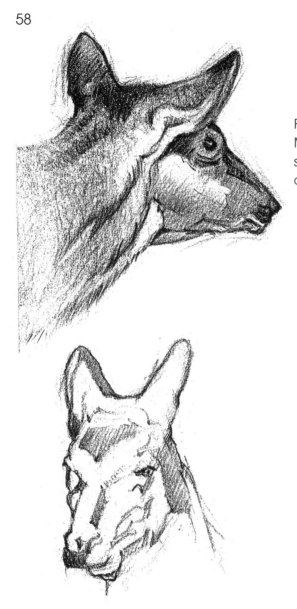

Fig. 66 (left). Arthur Monrad Johnson; scientific sketches of animal heads

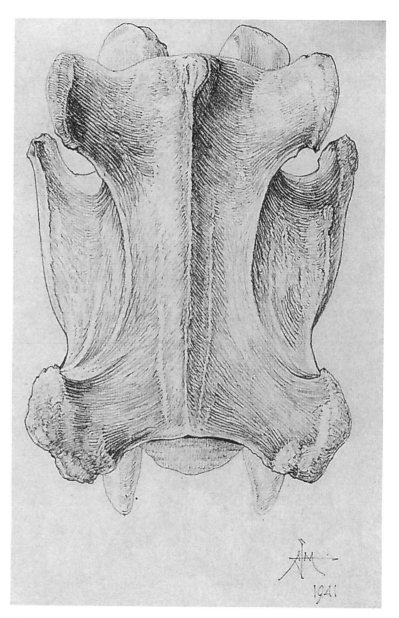

Fig. 67. Arthur Monrad Johnson; detail of skeletal structure

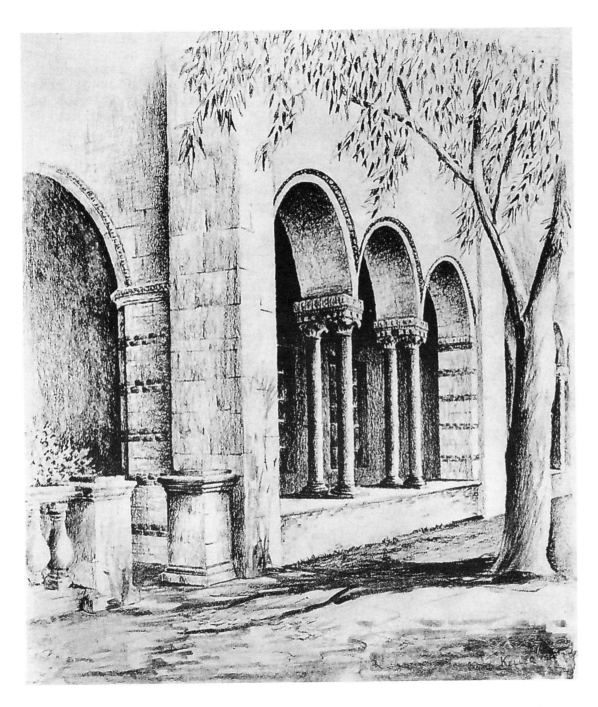

7. Sketching and Rendering in Architecture and Landscape Architecture

Now try some architectural situations; details at first, and more complete monumental forms later. Endeavor to select and use appropriate principles discussed in the foregoing pages.

Attempt to bring your drawing to a more complete and satisfactory conclusion.

Seek dramatic effect through strong contrasts of light and shade; use this emphasis to achieve a definite focal point of interest by a concentration of either dark *or* light values.

Fig. 68 (left). Architectural sketch in pencil, example of contrasts in values

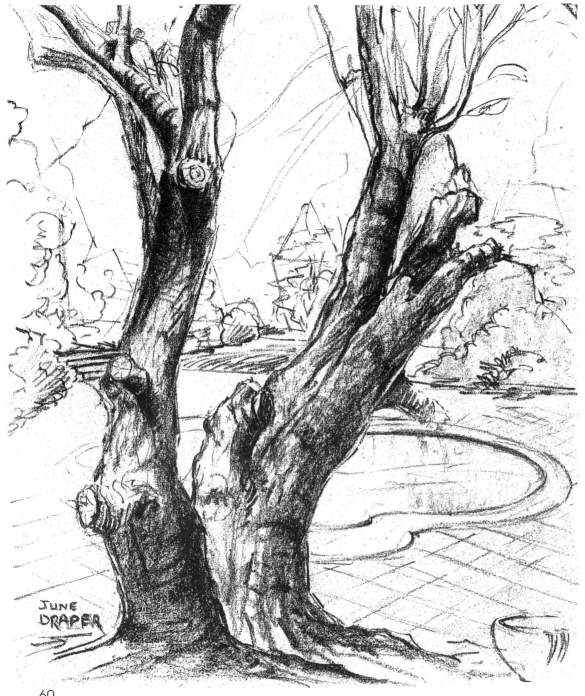

JUNE
DRAPER

a. Development of "Character"

Now try some architecture-landscape combinations. Attempt to develop your ability to present the *character* of your subject matter as well as correct spatial extensions and proportions of mass.

You might give some thought to the very acceptable truth that your way of drawing can be as individual as your handwriting. The autographic element, felt or seen, is one sure attribute of good drawing.

Figures 69 and 73 are good examples of student attempts to achieve an autographic quality and fidelity to nature *without* photographism.

Fig. 69 (left). "Character" in a pencil sketch combining natural and formal elements

b. Professional Architectural Rendering

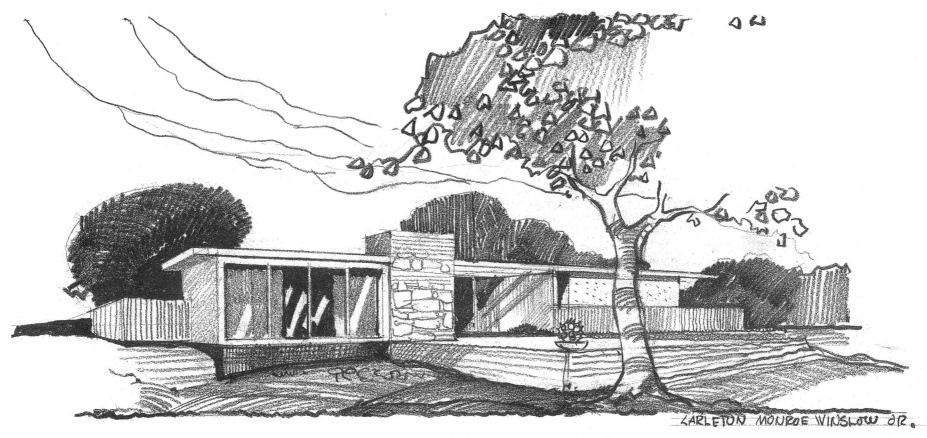

Fig. 70. Carleton Monroe Winslow, Jr., sketch of dwelling

Examine the three drawings (Figs. 70–72) by Carleton Monroe Winslow, Jr., Architect, for the application of perspective, versatility of line, calligraphy, and general balance in relation to the frame. In Figure 70, the architect has employed all of these resources of the artist, in varying degrees. Note, in the design of the house, the use of simple prisms of solid and void, all nicely balanced. Observe also the variety of textures, especially the strength or delicacy of line in the fences and in the chimney structure, and the coarse lines used in the tree forms and shaded areas. The ellipse has been used to create a tree *leaning*, not to the left or right of the observer, but away from him—a much more difficult undertaking.

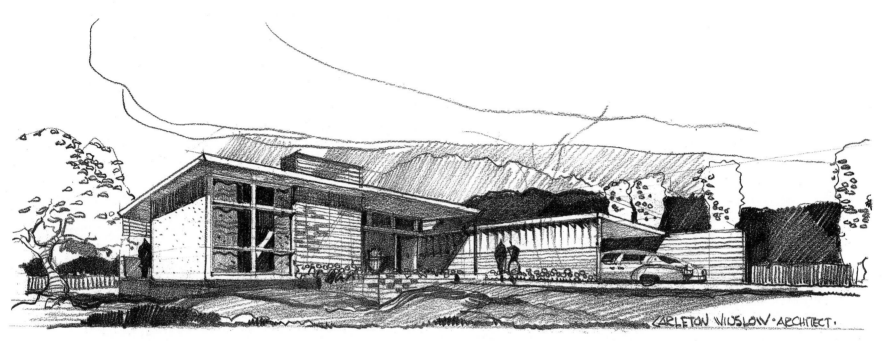

Fig. 71. Pencil sketch of a dwelling, by the architect, Carleton Monroe Winslow, Jr.

Figure 71, above, and Figure 72, on the opposite page, are further demonstrations of perspective principles; note especially the use of the principle of intersecting inclined planes in Figure 72. Both drawings are characterized by an interesting disposition, or pattern, of textures, and in the sketch of the dwelling this pattern is enhanced by the suggestion of intensely sunlit atmosphere, with very pleasing result.

The sketch shown in Figure 71 was drawn entirely freehand, with the assurance and skill of the professional architect. Note what a remarkably straight line training and practice can produce—the kind of line we often hear the lay person say he cannot draw! Practice does indeed make perfect.

Note the esoteric line the architect uses to "fill in" the space of sky—a few simple but eloquent lines to suggest clouds.

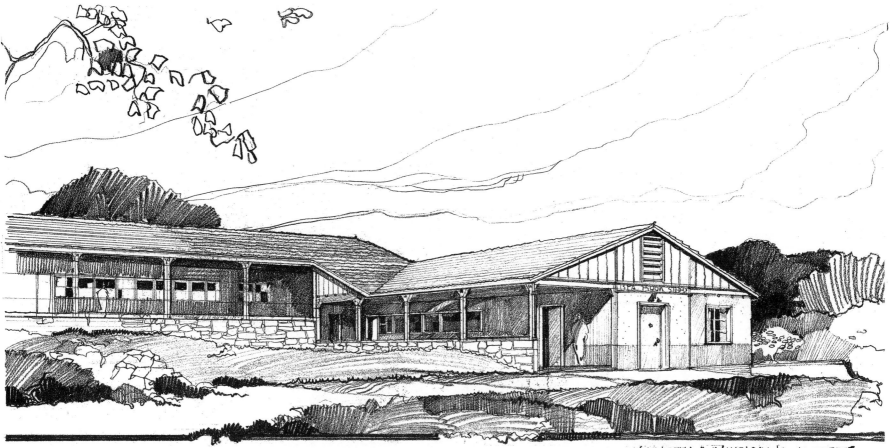

Fig. 72. Sketch by the architect, Carleton Monroe Winslow, Jr., of Parish School,
Episcopal Church of the Ascension, Sierra Madre, California

The above reproduction is approximately half the size of the original.

Architectural drawing is highly functional, and in this instance the functions are description and suggestion. For greater exactness, the architect has used both ruler and triangle. However, the textures surrounding the building are sufficiently powerful to be dominant, and the casual observer is therefore practically unconscious of any ruled lines.

The drawing is an example of the use of the architect's privilege to exaggerate for blueprint and builders' requirements; he deliberately exceeds the normal range of vision of 60 degrees at the station point.

8. Sketching for Enjoyment

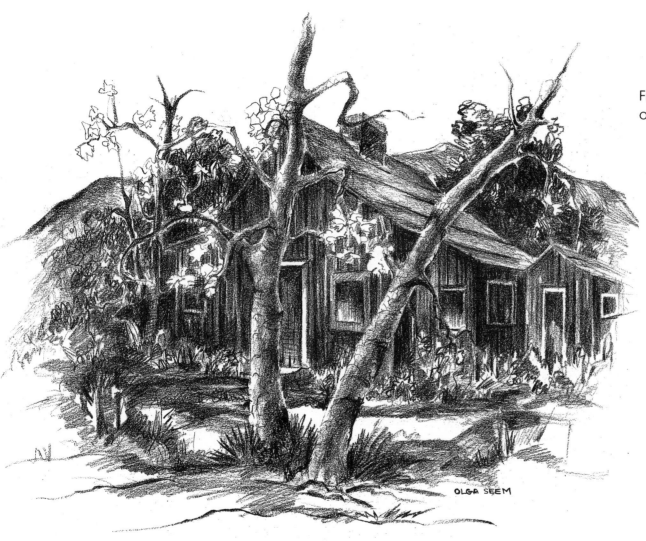

Fig. 73. Student sketch, an old house

The student artist has drawn this sketch purely for pleasure. Get experience in drawing something old, as well as something new—old houses, old places, old things, even old people. Drawing itself has a high therapeutic value. The importance of relaxation and the enjoyment of useful hobbies is not to be overlooked.

9. Landscape Drawing

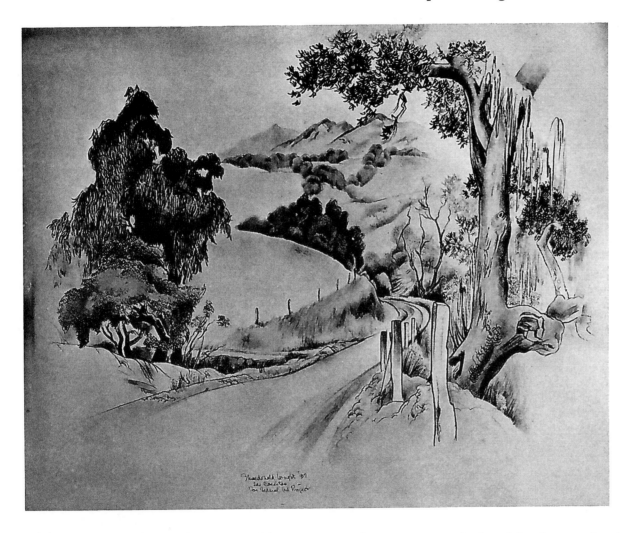

Fig. 74. S. Macdonald Wright;
pencil drawing,
Las Casitas Canyon

The artist has shown, by virtue of his mastery of certain perspective principles, a deep appreciation of his medium, the pencil. He uses a combination of outlined and un-outlined forms, with an assortment of pleasing textures arranged in an appealingly patterned whole. His carefully calculated background values maintain an over-all adherence to a single-plane concept, so that the perspective depth created by the winding road's convergence downhill (assisted by diminishing heights, thicknesses, and placement of the fence posts) becomes psychological.

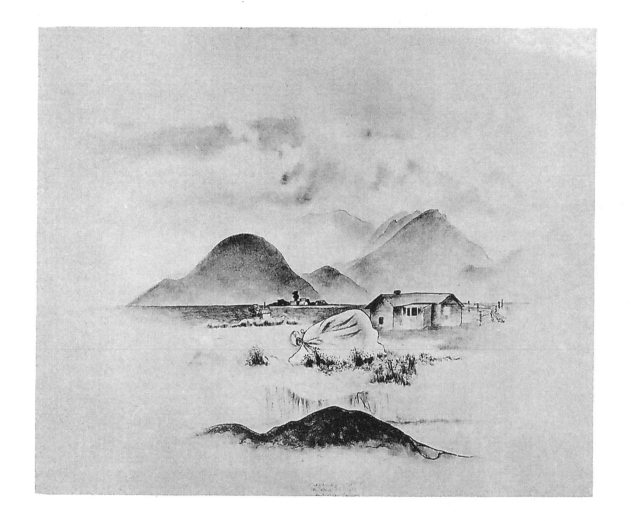

Fig. 75. S. Macdonald Wright;
pencil drawing, *Point Mugu*

Study the invocation of elements of aerial perspective in this drawing, and note especially the areas of diminished values where distance is indicated. The vignetting (fading out all round) of the drawing surface creates an effect of self-containment.

The artist has used the pencil effectively to express mood.

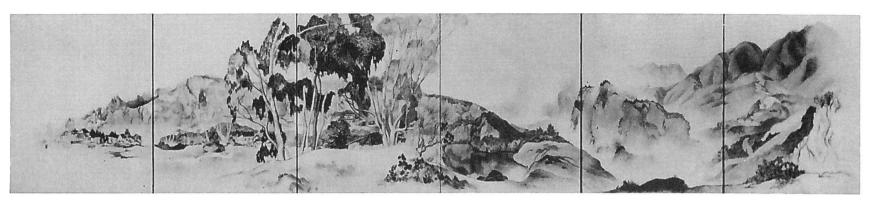

Fig. 76 (above). S. Macdonald Wright; pencil drawing, *Santa Monica Canyon* (six panels, each 29″ high, 21″ wide)

The drawing reproduced as Figure 76 is done in the Makimono style, that is, in a long horizontal roll; hence its unusual dimensions. The strongly Oriental idiom, characteristic of this particular artist, is again prominent. Here is drawing as communication; not the literal transcribing of a scene, but a graphic recording of the essential characteristics—temper, mood, and spirit—of a place in time. The vignette of the whole, again, suggests self-containment, an intrinsicality like that of a Shangri-la.

Careful study of the enlarged detail in Figure 77 will reveal to some degree the techniques used in creating the textures of the eucalyptus trees. Note, too, the firm and decisive manner in which line has been used.

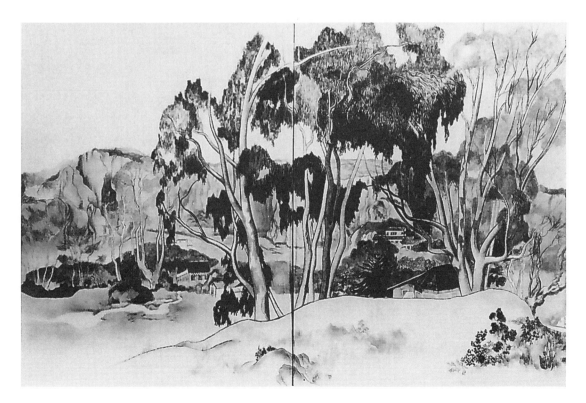

Fig. 77. Detail of two panels of *Santa Monica Canyon* (compare with Fig. 76).

PART TWO

• THEORY · BASIC LAWS and PRINCIPLES
of
PERSPECTIVE

I. THEORY OF PERSPECTIVE

A perspective drawing is an image of an object projected upon an assumed plane, parallel, ordinarily, to the observer's face. An imaginary pane of glass between the object and the observer's eyes well represents the plane on which the object seen may be drawn.

Visual rays, or light rays, extend from every part of the object to the eye, and vice versa, and thus penetrate the plane of glass. If *all* the points of penetration on the glass were connected, an image would appear on the glass plane, of a size relative to the distance of the object from the imaginary plane.

Note that, in Figures 78, 80, and 81, objects actually equal in size differ in apparent size, on the glass plane.

The assumed glass plane is known as the picture plane (PP), a term frequently used throughout the study of perspective. For practical purposes, this picture plane may be regarded as virtually identical with the student's drawing paper or other material.

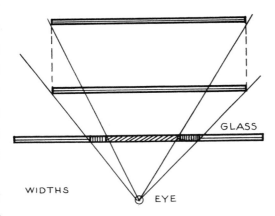

Fig. 78. Plan: light rays, piercing picture plane and converging toward the eye

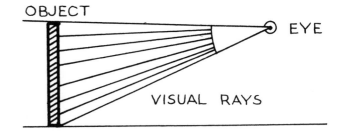

Fig. 79. Vertical section: visual rays converging toward the eye

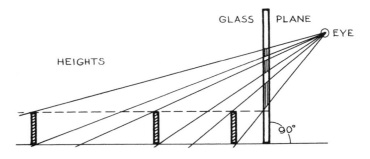

Fig. 80 (above). Relative heights, on picture plane, of vertical objects of same real height at various distances

Fig. 81 (right). Equal horizontal depths of objects differ relatively in their apparent size on the glass picture plane

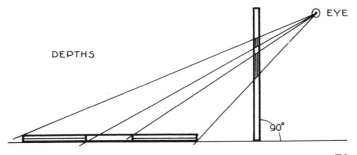

II. PRINCIPAL TERMS DEFINED

1. The Picture Plane (PP)

The picture plane (PP) is nearly always assumed to be parallel to the observer's face or eyes. If the image produced upon the glass (as indicated on p. 71) is inscribed on it, a tracing of this image, made upon paper, would be a perspective drawing.

The image drawn on the picture plane in the accompanying photograph is that seen by the observer, who is at the station point, or eye.

Note that there is a great reduction in the apparent size of the object in even a relatively short distance.

The contour edges of the actual object ABCD correspond to those on the picture plane drawing.

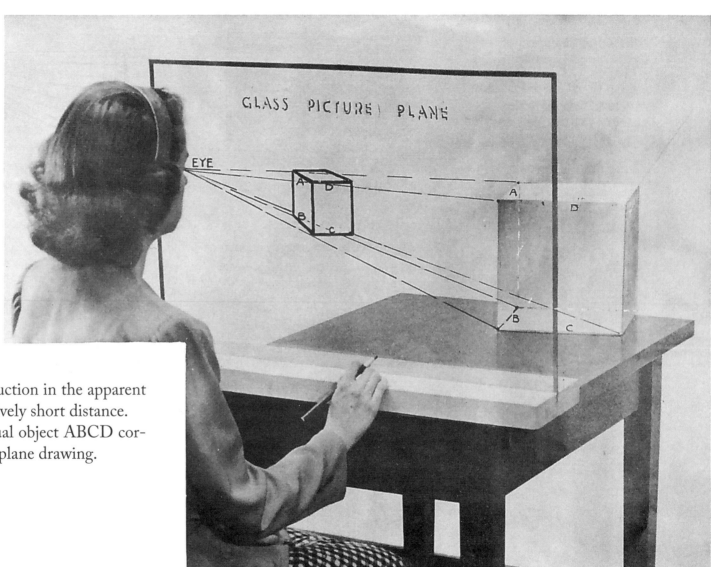

Fig. 82. Image on transparent picture plane

Figures 83 and 84 afford a further explanation of the picture plane, to inform the student of the method by which the eye level is established.

In Figure 83, the shaded imaginary plane represents a vertical section of the pathway taken by the ground plane when folded down.

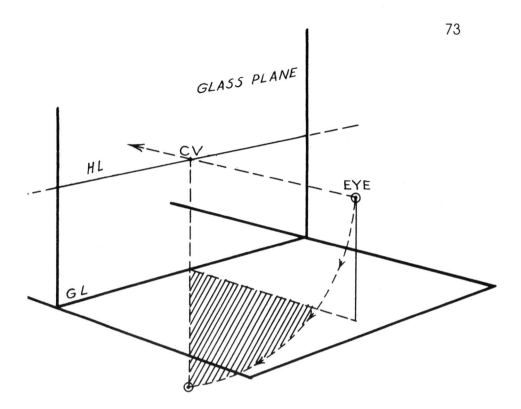

Fig. 83. Relation of eye (or station point) to ground plane, picture plane, and center of vision

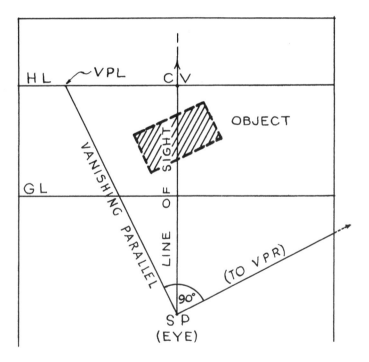

Fig. 84. Diagram: result of making line of sight and ground plane continuous with picture plane

Figure 84 represents the plan resulting from folding down the ground plane (see Fig. 83) so that it is continuous with the picture plane. The horizon line, or eye level, is as far from the ground line as the eye formerly was above the ground.

A plan of an object may now be drawn in the space between the horizon line and the ground line, with the line of sight passing through its approximate center.

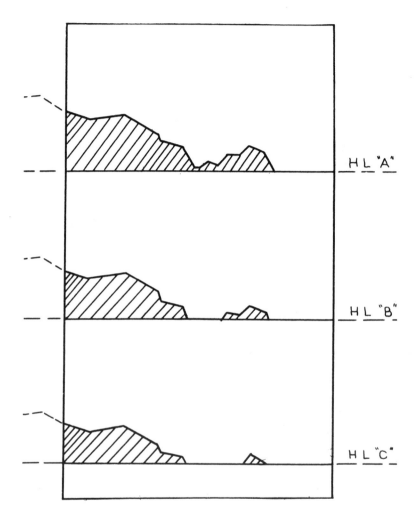

Fig. 85. Position of the horizon line: "A," high; "B," medium; "C," low

2. The Horizon Line (HL) or Eye Level (EL)

The horizon line represents the observer's eye level.

In Figure 85, the position of the horizon line "A," as compared with the position of horizon line "B" and that of horizon line "C," indicates that the observer must have been stationed at a higher altitude.

The horizon line is immeasurably important, for on it is based the entire perspective system of an object.

Figure 86, below, illustrates the fact that the horizon line is a continuous line around the observer.

Remember the following principles:

(1) The horizon line is constantly at eye level and lies on the picture plane.

(2) The horizon line is raised or lowered according to the changing altitude of the observer.

(3) The artist looks up to see objects above the horizon line, straight ahead to see objects on the horizon line, and down to see objects below the horizon line.

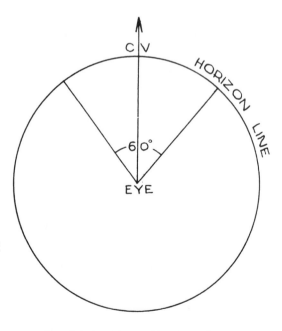

Fig. 86. Position of horizon line in relation to observer

3. The Line of Sight (LS)

The line of sight is the shortest distance from the observer to the picture plane. It is also known as the central visual ray and is directed toward the general center of the picture (see Fig. 87). The point at which it pierces the picture plane, on the horizon line, is called the center of vision (see CV in Fig. 88 below and in Fig. 86).

4. The Station Point (SP), or Eye

The station point is the point of the observer's position, opposite the general center of the picture (see Fig. 88). Its location is found by: (1) horizontal distance from the object, and (2) height above ground (see Figs. 78, 80, 81).

The station point may be located in the manner illustrated in Figure 88, as follows: On the line Left-Right, at eye level, describe a semicircle. The station point will be found somewhere on this semicircle. The line of sight, which is perpendicular to the eye level, or horizon line, will intersect the semicircle at the station point.

Remember: The station point could fall anywhere on the semicircle.

The lines called "vanishing parallels" are also illustrated in Figure 88. Observe that these lines, drawn from the station point to the points Left and Right, respectively, will form a right angle.

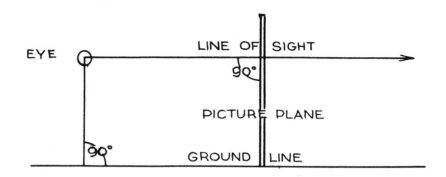

Fig. 87. The relation of the line of sight to observer, picture plane, and ground line

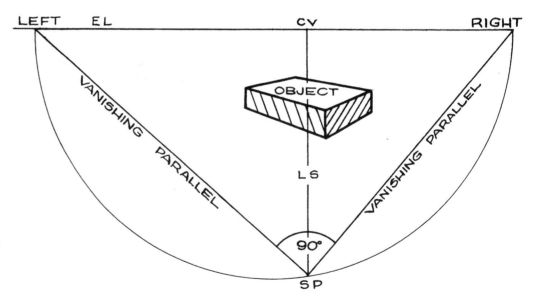

Fig. 88. Method of locating the station point

5. Range of Vision (RV), or Cone of Vision

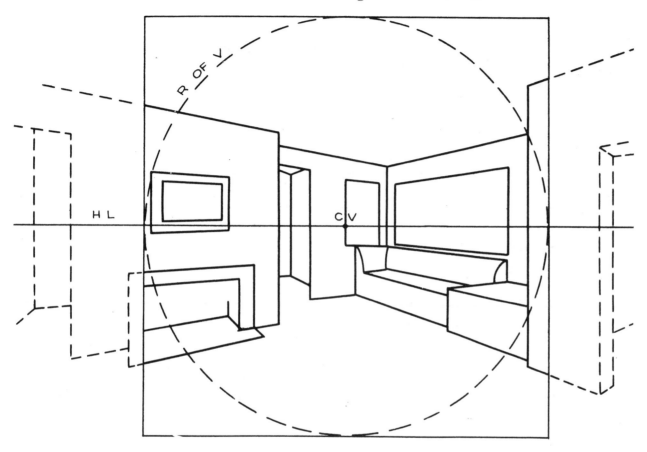

Fig. 89. The range of vision in the drawing of an interior

There is a limit to the range of vision of the human eye. You may therefore draw only that part of the picture which is seen comfortably, without turning the head. Otherwise, parts of the picture outside that range will be distorted.

Avoid the common error of including too much in the picture (see Fig. 89).

(CV in Fig. 89 represents the *center* of vision.)

The figure below (Fig. 90) shows how the cone of vision functions. Here, it is constructed on an angle of 45 degrees; an angle of 45 to 60 degrees is considered the maximum for the range of vision.

Example of the use of the cone of vision: If the observer wished to include more of the interior than is contained within the range of vision in Figure 89, it would be necessary for him to increase his distance from the group of objects until his range of vision attained the desired diameter.

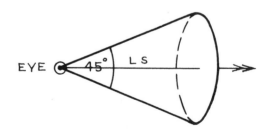

Fig. 90. The cone of vision

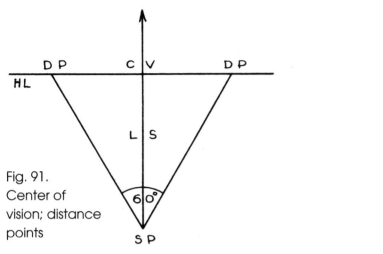

Fig. 91.
Center of
vision; distance
points

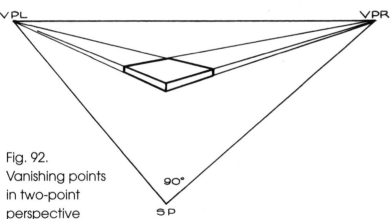

Fig. 92.
Vanishing points
in two-point
perspective

6. The Center of Vision (CV)

The center of vision is the point of intersection of the line of sight and the horizon line (see Fig. 91).

7. The Distance Point (DP)

The distance points are the points where the outer visual rays of the cone of vision intersect the horizon line. They are placed on either side of the center of vision, forming a distance equal to or slightly greater than that of the station point from the center of vision (see Fig. 91).

8. The Vanishing Point (VP)

The vanishing point is the point on the horizon line (or vanishing trace; see Fig. 94) toward which all of a group of parallel edges of an object will converge (see Fig. 92). Some vanishing points may be above or below the horizon line, as explained later, in the discussions of inclined planes and the vanishing trace.

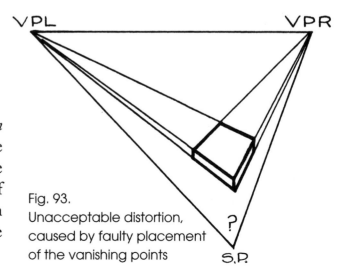

Fig. 93.
Unacceptable distortion,
caused by faulty placement
of the vanishing points

The distance between vanishing points is established by the points of intersection of the vanishing parallels on the horizon line, diverging from the station point (see Fig. 88, p. 75). Vanishing points for an object will move along the horizon line according to the ratio of rotation of the object or the change of position of the observer. It is wrong to place the vanishing points too close together, as in Figure 93. The eye will refuse to accept too great distortion. Remember: the closer the vanishing points, the greater the distortion.

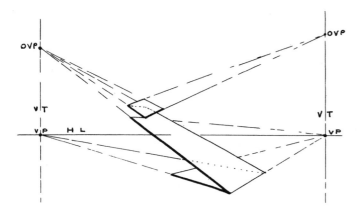

Fig. 94. Vanishing traces in two-point perspective; also, oblique vanishing points for inclined planes

9. The Vanishing Trace (VT)

A vanishing trace is a vertical or oblique line, or vanishing parallel, passing through a vanishing point on the horizon line.

On this vanishing trace is located another vanishing point, which is the point of convergence of a set of receding parallels for inclined planes; it is called the oblique vanishing point (OVP; see Fig. 94).

10. The Ground Line (GL)

The ground line is a convenient line used in making a scale of measurements. Undistorted units of measurement may be shown thereon. It is sometimes called the base line (see Figs. 95, 99).

11. The Measuring Point (MP)

A measuring point is a point on the eye level or horizon line toward which measuring parallels appear to converge (see Fig. 95).

A measuring point is at a distance from its vanishing point equal to the distance from the station point to that vanishing point; it is taken along the eye level or horizon line.

The above rules apply to two-point perspective. To locate measuring points for one-point perspective, see Figure 108.

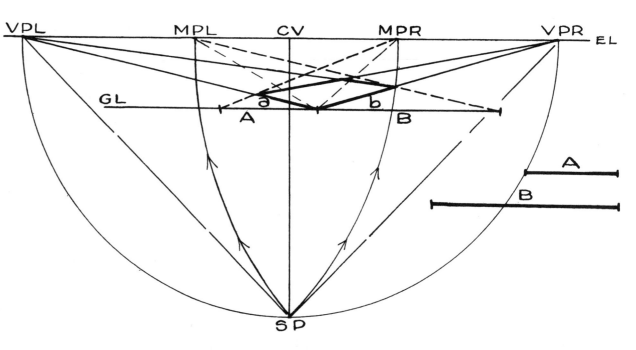

Fig. 95. Measuring points in two-point perspective.
A and B = given lines; a and b = A and B foreshortened

III. BASIC LAWS

Basic Law No. 1

All parallel receding lines of one set *appear* to converge at a common point (Fig. 96).

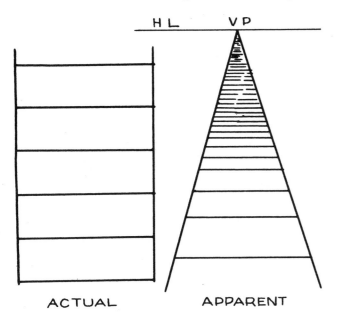

ACTUAL　　　APPARENT

Fig. 96 (above). Apparent convergence of receding parallel lines

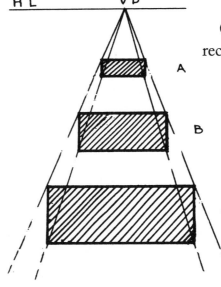

Fig. 97. Apparent diminution in accordance with distance from observer

Basic Law No. 2

Objects of equal size *appear* smaller as they recede into the picture (see Fig. 97, at left).

Fig. 98. Position of station point with relation to the picture

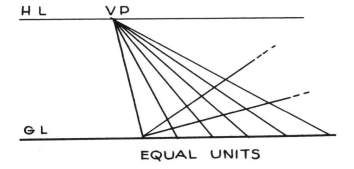

EQUAL UNITS

Fig. 99. Ground line of a given plane and its relation to the horizon line of that plane

Basic Law No. 3

The station point is opposite the general center of the picture. Its distance from the center of vision is approximately equal to the greatest dimension of the picture (see Fig. 98, above).

Basic Law No. 4

The ground line (or base line) gives undistorted units of measurement; it is always parallel to the horizon line of its own plane (see Fig. 99 and compare with Fig. 103).

79

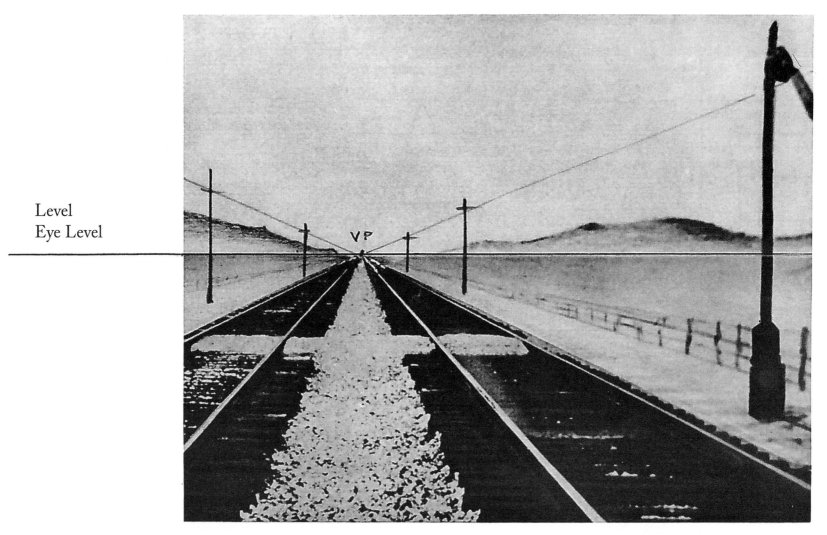

Level
Eye Level

VP

Fig. 100. Apparent convergence of actually parallel lines

Figure 100 illustrates graphically, in terms of a familiar scene, the fact that actually parallel receding lines appear to converge at a common point (Basic Law No. 1).

Basic Law No. 5

Angles of direction are dependent upon the line of sight (see Fig. 101).

Basic Law No. 6

The cone principle: The more the apex of a conical object is turned away from the observer, the less he sees around the object. Conversely, the more the apex is turned toward him, the more he sees around the object (see Fig. 102). Remember: farther—less; nearer—more.

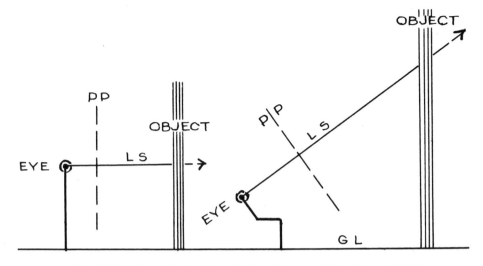

Fig. 101 (above). Angles of direction and the line of sight

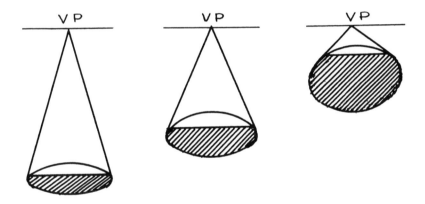

Fig. 102. The cone principle

Basic Law No. 7

The horizon lines for inclined planes (see Fig. 103) are parallel to their own ground lines. Measuring points for inclined planes are taken along their own horizon lines.

In Figure 103, the ground line marked GL2 is that of the object resting on the inclined plane, and the horizon line

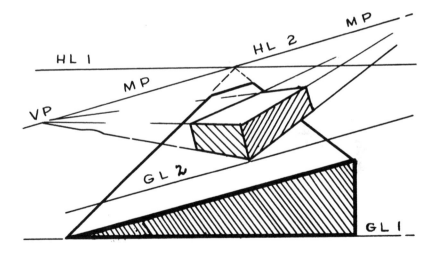

Fig. 103. Inclined plane and its ground line, horizon line, and measuring points

(HL2) for that ground line is therefore parallel to it. The measuring points for this object will be established on the inclined horizon line, HL2.

IV. SUMMARY OF PRINCIPAL TERMS AND BASIC LAWS

1. Principal Terms

(1) Picture Plane
(2) Horizon Line, or Eye Level
(3) Line of Sight
(4) Station Point, or Eye
(5) Range of Vision, or Cone of Vision

(6) Center of Vision
(7) Distance Point
(8) Vanishing Point
(9) Vanishing Trace
(10) Ground Line
(11) Measuring Point

2. Abbreviations, Alphabetically Listed

CV Center of Vision
DP Distance Point
EL Eye Level
GL Ground Line
HL Horizon Line (or Eye Level)
LS Line of Sight
MP Measuring Point

OVP Oblique Vanishing Point
PP Picture Plane
RV Range of Vision
SP Station Point
VP Vanishing Point
VT Vanishing Trace

3. Basic Laws

No. 1. All the parallel receding lines of one group appear to converge at a common point.

No. 2. Objects of equal size appear smaller as they recede into the picture.

No. 3. The station point is opposite the general center of the picture. Its distance from the center of vision is approximately equal to the greatest dimension of the picture.

No. 4. The ground line (or base line) gives undistorted units of measurement; it is always parallel to the horizon line of its own plane.

No. 5. Angles of direction are dependent upon the line of sight.

No. 6. The cone principle: The more the apex of a conical object is turned away from the observer, the less he sees around the object. Conversely, the more the apex is turned toward him, the more he sees around the object.

No. 7. The ground lines for inclined planes are parallel to their own horizon lines. Measuring points for inclined planes are taken along their own horizon lines.

4. "Paste-on" Exercise

Figure 104, below, illustrates some of the principal terms and basic laws. The student should look for a suitable large object, such as a house (interior or exterior), or a photograph of a single, smaller object, such as a table or chair. An advertisement in a newspaper or magazine would be satisfactory.

Mount the picture of the object on a large sheet of newspaper and use the procedure demonstrated in the accompanying figure. Look for the level edges known to be parallel and, with a pencil, extend the lines of each group of parallels until they meet at a vanishing point. This point should be on the photographer's eye level.

Now find illustrations of as many of the principal terms as possible, and label these examples as you proceed.

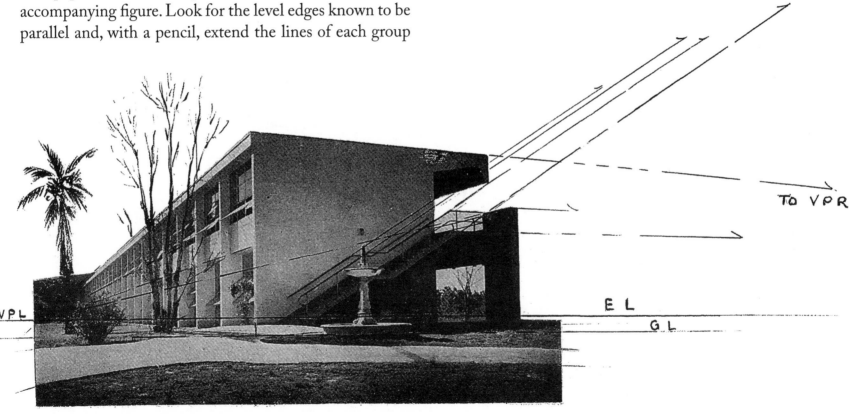

Fig. 104. Illustration of the principal terms of perspective by means of a "paste-on" exercise

V. THE THREE TYPES OF PERSPECTIVE

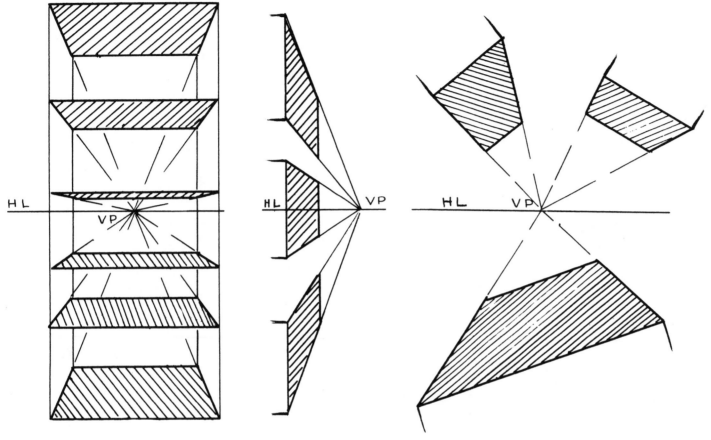

Fig. 105. Horizontal receding planes

Fig. 106. Vertical receding planes

Fig. 107. Oblique receding planes

The types of perspective are classified according to the number of vanishing points used in drawing an object. The number of vanishing points is dependent on the position of the object with relation to the picture plane.

Remember: The position of the vanishing points may be changed relatively by (1) moving away from or toward the object; (2) moving or turning the object; or (3) raising or lowering the eye level, by the observer's changing his altitude.

1. One-point Perspective

a. Definition

When two sets of the principal edges of an object are parallel to the picture plane, and the third set is perpendicular to the picture plane, the result is one-point, or parallel, perspective.

b. Ascending and Descending Two-dimensional Planes

Note: You look *up* to see objects *above* the horizon line, *straight ahead* to see objects *on* the horizon line, and *down* to see objects *below* the horizon line.

84

c. One-point Perspective Projection

In Figure 108, observe that the distance of the station point from the center of vision in the plan (SP1 and CV1) is the same as the distance of the station point from the center of vision in the perspective view (SP2 and CV2).

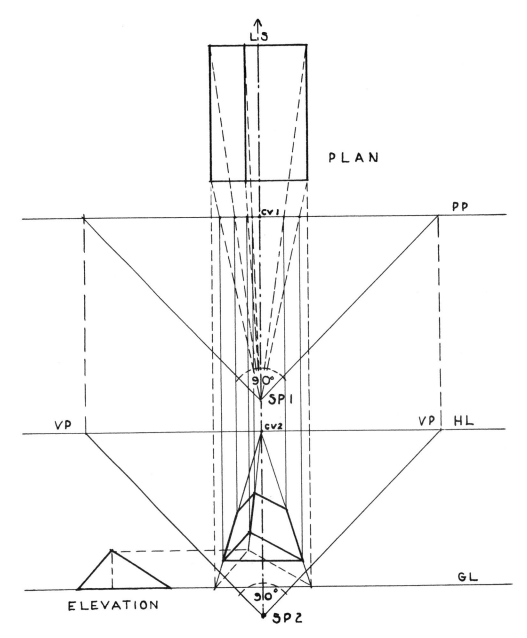

Fig. 108. One-point perspective projection

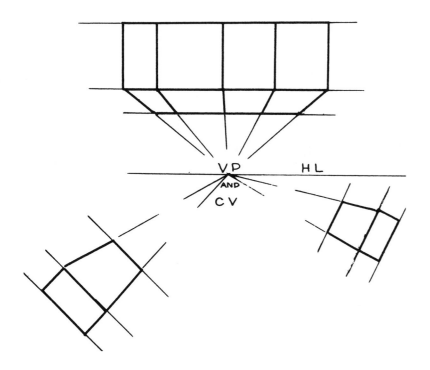

Fig. 109. Objects in parallel perspective, in various positions relative to the center of vision and ground level

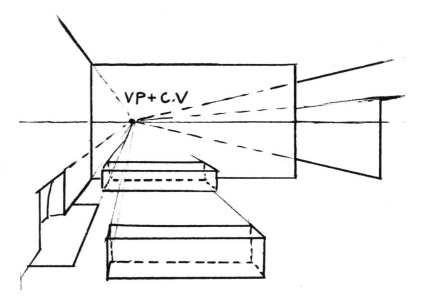

Fig. 110. View of an interior, in one-point perspective

Observe that the actually parallel edges of the surfaces parallel to the picture plane (those facing the observer) remain parallel in perspective; they do not converge. However, the receding edges of all surfaces perpendicular to the picture plane (including the walls, the floors, and the ceiling) are *all* parallel to one another and, in perspective, converge toward a common vanishing point.

d. Further Uses of
One-point Perspective

In the drawing at the right, the edges of surfaces parallel to the picture plane, and to the observer's face, do not converge.

All receding edges of surfaces perpendicular to the picture plane converge toward a common point (compare with Figs. 109, 110, on p. 86).

Note, in the tower, the construction of the axis of rotation (see explanation on pp. 114, 115).

Fig. 111.
Street scene,
in one-point perspective

1) Views from Unusual Station Points

In Figure 112, and also in Figure 113, the walls are perpendicular to the picture plane, and their upright edges therefore appear to converge toward a common point. The actually horizontal rooftops are parallel to the picture plane; consequently, the lines belonging to each set of parallel horizontal edges of the roofs do not converge. Note the right angles at the corners of the level roofs.

Fig. 112. Upward view in
one-point perspective

Fig. 113. Downward view in
one-point perspective

2. Two-point Perspective

a. Definition

When only one set of the principal edges of an object is parallel to the picture plane, the lines of the two remaining sets of edges will converge respectively toward two points on the horizon line (HL or EL) and the result is two-point, or angular, perspective.

b. Projection

The line A in the upper part of the accompanying drawing (Fig. 114) is shown in perspective as A^1 in the lower part of the drawing, on the ground plane. It is the distance of the object from the picture plane.

Note that the upper vanishing points (VPL and VPR) are directly above their equivalents in the perspective view.

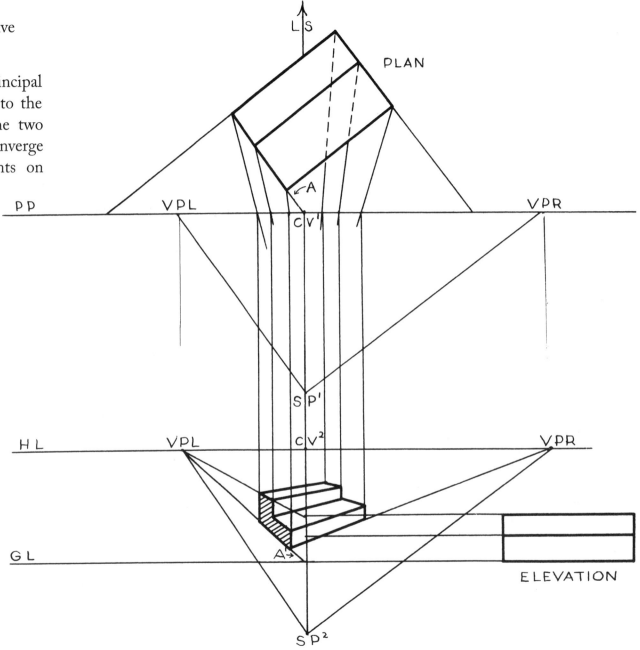

Fig. 114. Projection in two-point perspective

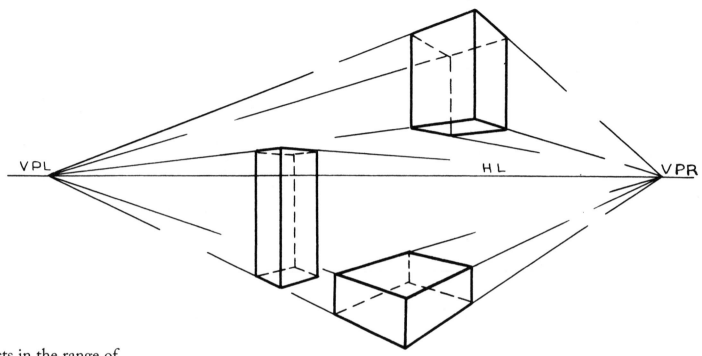

If all the objects in the range of vision have the same set of vanishing points, then the corresponding surfaces of all those objects must be actually parallel to one another.

Fig. 115. Two-point perspective: relationship of objects in various positions but having the same set of vanishing points

The drawing of a group of objects not having planes parallel to one another requires rather careful preparation, as is illustrated in Figure 116. Observe the locations of each set of vanishing points for each object, and note that the semicircles for each of the three sets requiring two-point perspective (objects 1, 2, 4) intersect at the same point, which, for practical purposes, may be regarded as coinciding with the station point. Object 3, because of its position, requires only simple, one-point perspective.

Note also that all the objects are within the comfortable range of vision.

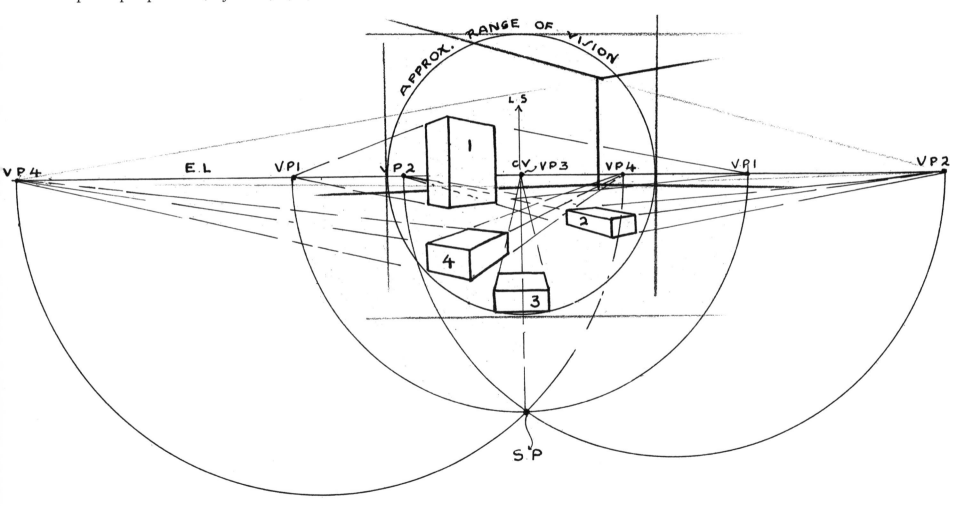

Fig. 116. Method of drawing a group of nonparallel objects (1, 2, 4) in two-point perspective

c. Multi-vanishing-point Perspective

Multi-vanishing-point perspective is necessary for the drawing of planes which are not parallel to one another, as in Figure 117, below.

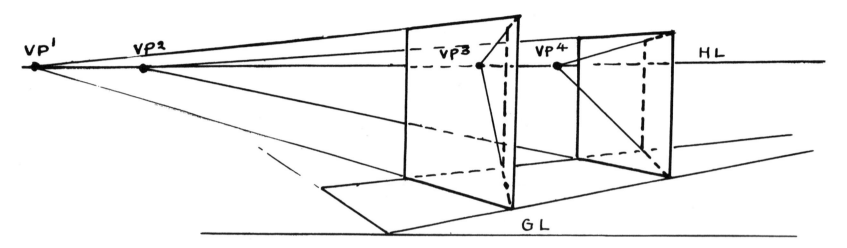

Fig. 117. Multi-vanishing-point perspective

d. Box Construction

The student will find that box construction is a useful method of drawing complex objects in two-point perspective, as illustrated in Figures 118 and 119.

Fig. 118. Application of box construction to the drawing of an irregular object

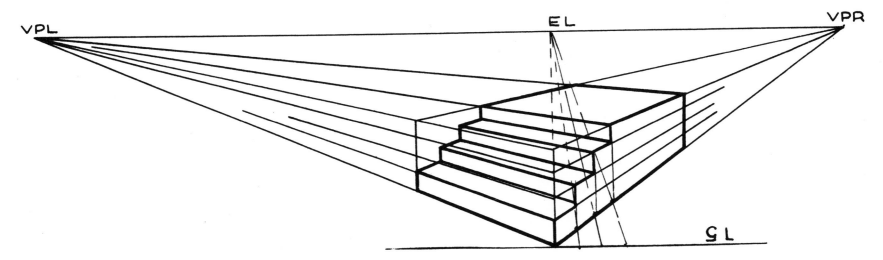

Fig. 119. Application of box construction to the drawing of a regular but complex object

3. Three-point Perspective

a. Definition

When all three sets of the principal edges of an object are inclined to the picture plane, the three sets of edges will converge respectively toward three vanishing points, and the result will be a three-point perspective drawing (see Fig. 122).

b. Comparison of the Three Types of Perspective

Compare Figures 120, 121, and 122. Observe that in Figure 122 all the planes of the structure represented, as well as all its edges, are inclined to the picture plane.

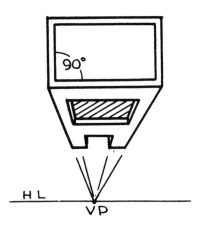

Fig. 120 (above). Parallel, or one-point, perspective

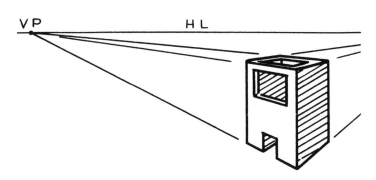

Fig. 121. Angular, or two-point, perspective

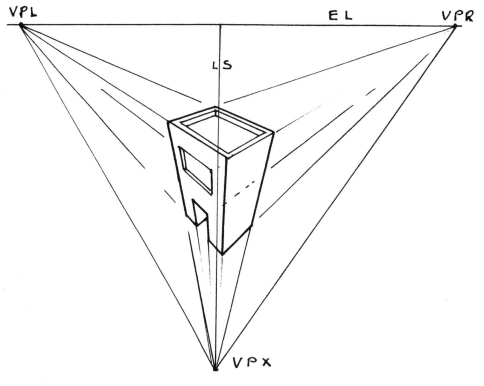

Fig. 122. Three-point perspective

c. Projection

The three-point projection for Figure 123, below, is found by transferring the ground line, the station point, and the three principal vanishing points—VPL, VPR, and VPX.

Other points, such as Nos. 1 through 7 and Nos. 8 through 14, may be transferred similarly, as is illustrated on the next page.

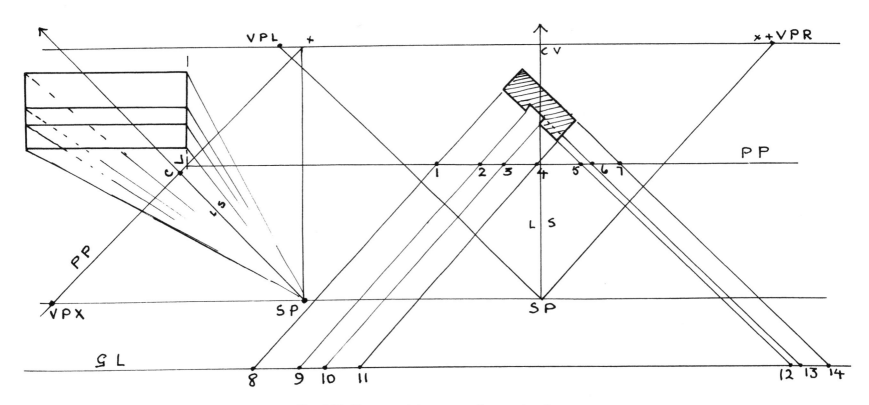

Fig. 123. Three-point perspective projection

The distance from VPX to CV in Figure 124 equals the distance from SP to CV in the left part of Figure 123, on the preceding page; and the distance from VPX to 0 in Figure 124 equals the distance from VPX to X in Figure 123.

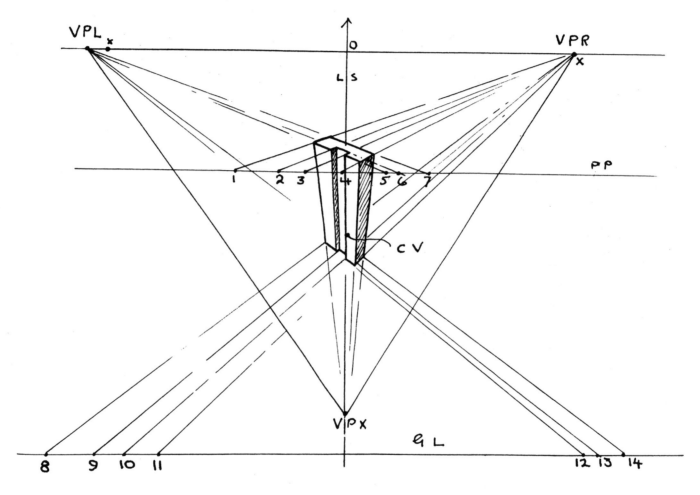

Fig. 124. Three-point perspective projection

d. Unusual Views with an Inclined Picture Plane

Compare Figures 125 and 126 with the drawings on pages 88 and 94. The principle of the angle of direction (Basic Law No. 5, p. 81) applies to all these illustrations, but only Figures 122, 125, and 126 are drawn with *all* principal planes inclined to

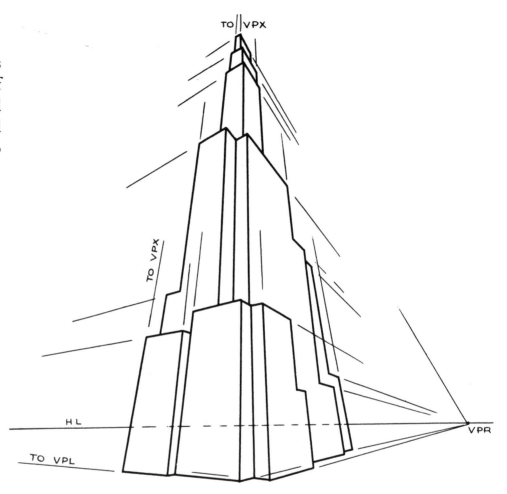

Fig. 125. Upward view with an inclined picture plane

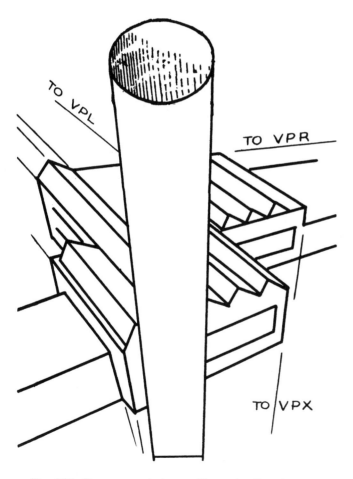

Fig. 126. Downward view with an inclined picture plane

the picture plane, and therefore with no set of edges parallel to the picture plane. Observe that in Figure 112 (p. 88), which does *not* have an inclined picture plane, the lines representing each group of actually parallel top edges of walls are *drawn* parallel, but in the figures on pages 96 and 97 the lines of each set *converge toward a vanishing point* belonging to that set alone.

VI. ISOMETRIC DRAWING

1. Definition

Isometric drawing is a convention in drawing in which the lines of the object represented appear in their true proportions (*iso*, "equal," + *metron*, "measure"). It is customary to use two 30-degree angles at the apex resting on the ground line.

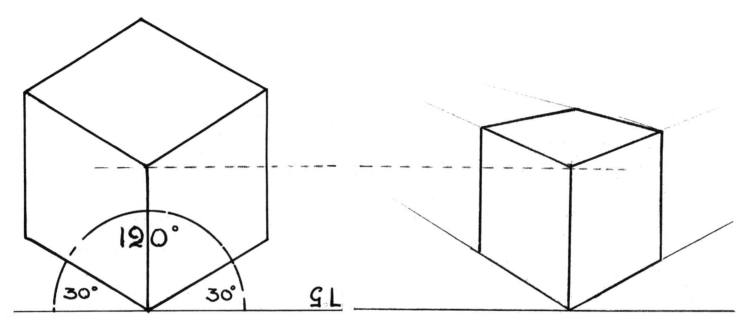

Fig. 127. Isometric cube Fig. 128. Perspectively drawn cube

2. Comparison of Cubes in Isometric and Perspective Drawing

a. Isometric Cube

In the isometric cube, all edges are of equal length, diagonally opposite angles on each surface are equal, and actual parallels are drawn parallel. Observe that the lines of each set of parallel receding edges seem to *di*verge rather than *con*verge (and compare this figure with Plate V, on page 4).

b. Perspectively Drawn Cube

In a perspective drawing of a cube, all edges known to be parallel to one another (except the vertical edges) are so drawn as to converge toward a vanishing point on the eye level.

3. Isometric Four-point Oval Compared with Perspectively Drawn Ellipse

The four-point oval in Figure 129 was constructed within a circumscribed *isometric square* (a square with sides actually drawn equal) which meets the ground line at the usual angles of 30 degrees and 30 degrees. A'- A' is the true major axis of the oval and lies on the line A - A, which intersects the left and right corners of the square. Each V is a point of tangency and also a midpoint of a side of the square; the X's are the centers of four circles, arcs of which form the oval. The ends of an isometric four-point oval, or four-centered oval, are much more round than the ends of an ellipse in perspective.

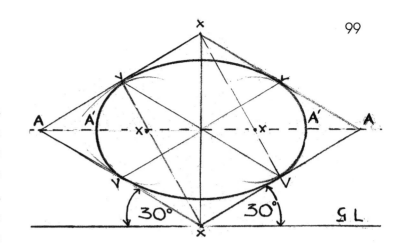

Fig. 129. A four-point oval

In a perspectively drawn ellipse, actually a foreshortened circle (Fig. 130), the major axis (not shown in Fig. 130, but marked A - A in Fig. 153, p. 111) passes through the *apparent center* (not true center) of the circle. The points of tangency in Figure 130 (the V's) occur at the actual centers of the sides of the perspectively drawn square. Unlike A - A in the isometric oval (Fig. 129), B - B in Figure 130 does not intersect the left and right corners of the enclosing square. Moreover, the line B' - B', which is coincident with that part of B - B lying within the ellipse, is not the major axis of the ellipse; instead, B' -B' is the horizontal diameter, equivalent to the line D - D in Figure 153, page 111.

For possible positions of the enclosing square, compare Figure 130 with Figure 163, page 115; and for a discussion of the ellipse, see the text on pages 111–115.

Fig. 130. An ellipse, or perspectively drawn circle

4. Isometric Drawing of an Interior

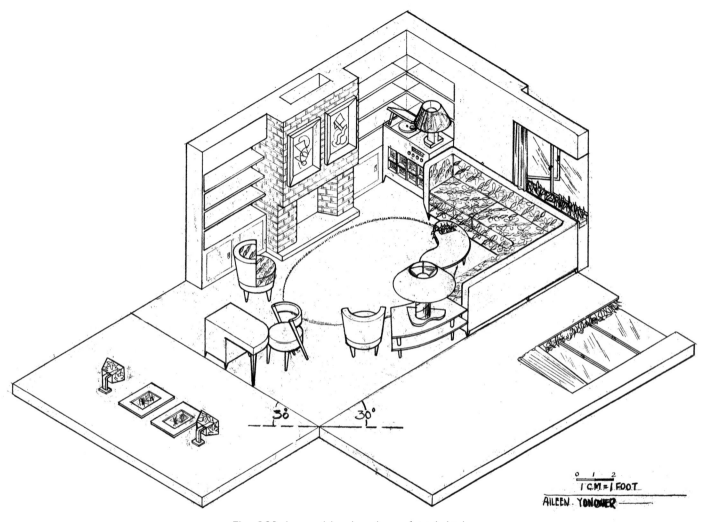

Fig. 131. Isometric drawing of an interior

In an isometric drawing, we draw what we *know* of an object's linear proportions, not what we *see*. If this principle is applied, as in the above drawing, then the isometric nature of the drawing will permit *true* linear measurements and hence, correct dimensions of objects and spaces alike,

without recourse to *measuring-point* deductions. Notice the difference in appearance between the "elliptical" objects in Figure 131 and those in the vase drawings in perspective, on page 30.

VII. MEASURING DEPTHS OF PLANES

There are three methods of measuring depths of plane surfaces: by diagonals (see Fig. 132); by a scale on the ground line (see Fig. 133); and by the plan principle (see pp. 85, 89, 95, 96, 103, and 104). These methods may be used for measuring depths above the horizon line, as well as below. (For measuring depths on curved surfaces, see pp. 112, 116, 117, and 118.)

1. Diagonal Method

To divide the length of a plane, vertically, into a number of parts, divide the nearest vertical line of that plane into the desired number of parts and extend lines therefrom to their vanishing points, as is shown in Figure 132. A diagonal of the rectangular plane will intersect these lines at the desired points. Note also (in Fig. 132) that objects of equal height (or width) may be drawn at any position within focus of the station point, by the use of vanishing lines.

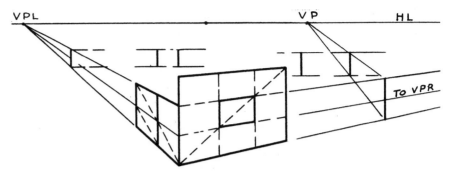

Fig. 132. Measuring depths, diagonal method

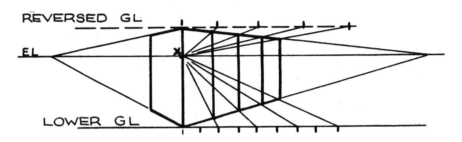

Fig. 133. Measuring depths by ground line scale

2. Ground Line Scale Method; Combination of Ground Line Scale and Diagonal Methods

The ground line scale method is illustrated in Figure 133. Draw a line diagonally from the eye level, at X, through any outside corner of the object to the ground line below, and another diagonal to a reversed ground line above the eye level. Divide the base of each triangle thus formed into the desired number of parts. Extend lines from the points on the ground line to the apex of the triangle. Intersections with the receding edges of the object are the desired points of division. Figure 134 illustrates the way in which this method and the diagonal method may be combined.

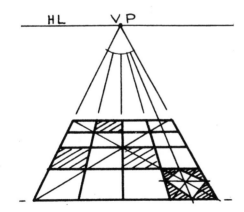

Fig. 134. A combination of the ground line scale and diagonal methods

101

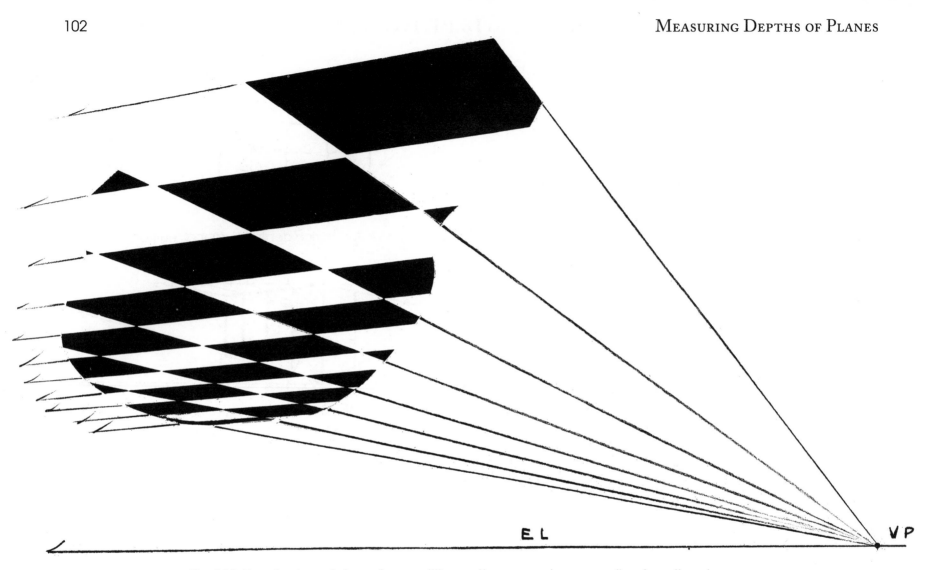

Fig. 135. Foreshortened view of a repetitive pattern on a plane receding from the observer

The accompanying illustration is a part of a photograph giving a well-foreshortened view of a square-checkered surface. Turn it upside down; the same perspective system applies. From the marked difference in the size of the squares, which we *know* to be equal, we observe that things do not, indeed, *appear* as they are and that objects of *actually* equal size *appear* to diminish as they recede into the picture. Use any standard method to arrive at the correct dimensions.

3. The Plan Principle

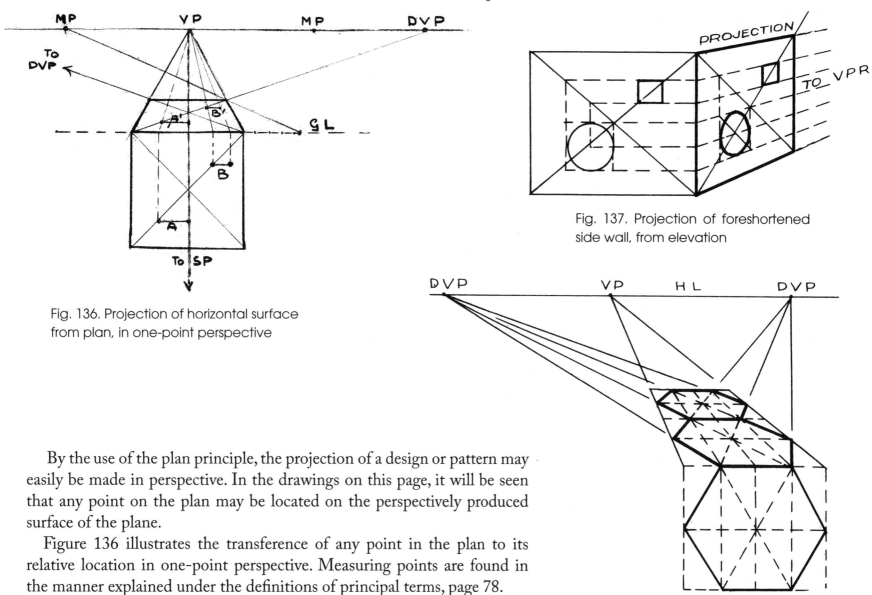

Fig. 136. Projection of horizontal surface from plan, in one-point perspective

Fig. 137. Projection of foreshortened side wall, from elevation

Fig. 138. Projection with diagonal vanishing points

By the use of the plan principle, the projection of a design or pattern may easily be made in perspective. In the drawings on this page, it will be seen that any point on the plan may be located on the perspectively produced surface of the plane.

Figure 136 illustrates the transference of any point in the plan to its relative location in one-point perspective. Measuring points are found in the manner explained under the definitions of principal terms, page 78.

Figures 137 and 138 are elaborations of the plan principle. Figure 138 illustrates the rule that diagonals also have their vanishing points (DVP's).

The plan drawing below shows the relative positions of objects in two dimensions. The projection also shows the objects in two dimensions. Height, or the third dimension, is discretionary.

Under the plan principle, the plan itself may be divided into any number of compartments of desired dimensions. Diagonals may then be drawn on the compartments and their projections, and the essential points located in those projections. By extending the vanishing edges of the base of any prominent object, thus formed, to the eye level, vanishing points for that object can be located, for a drawing in two-point perspective. Other objects can then be drawn in relative perspective.

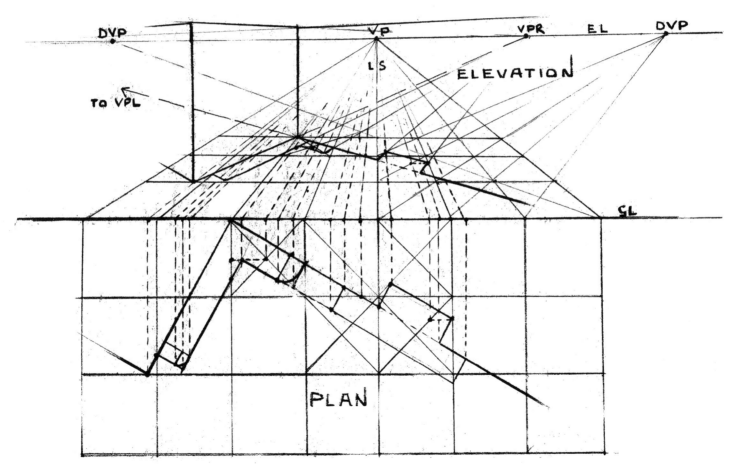

Fig. 139. Plan, elevation, and projection in two-point perspective

VIII. INCLINED PLANES

1. The Second Horizon Line, the Doubly Inclined Plane, and Intersecting Inclined Planes

In drawing an inclined plane it is necessary to establish a second horizon line, parallel to the ground line of that plane (see Fig. 140, and also pp. 78 and 81). The observer raises or lowers his head to determine the vanishing points of the parallels of the inclined plane, thereby creating a new eye level.

If a plane deviates from the level from left to right as well as from the front to the back (that is, if none of its edges is level), it is said to have a double incline, or to be doubly inclined (see Fig. 141).

Note the construction for drawing the intersecting inclined planes of the gable roof and the main roof, in Figure 142.

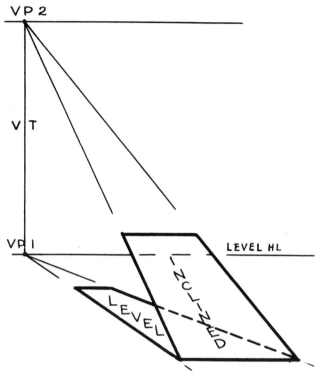

Fig. 140. Singly inclined plane

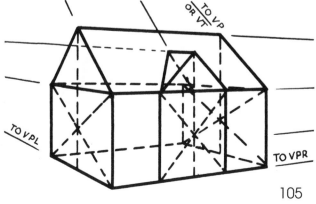

Fig. 142 (right). Roof with gable; example of intersecting inclined plane construction

Fig. 141. Doubly inclined plane

The direction of a plane *away* from the observer determines whether it is an uphill or a downhill plane.

In Figure 143, the vanishing point for the uphill inclined plane and that for the downhill plane are both on the vanishing trace, above and below the level horizon line, respectively.

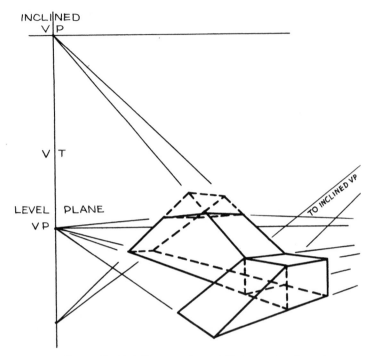

Fig. 143. Uphill and downhill singly inclined planes

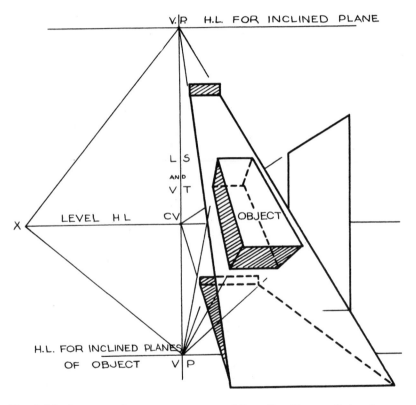

Fig. 144. Apparent convergence of "vertical" parallels of an object resting on an uphill inclined plane

In Figure 144, all angles of the object resting on the inclined plane are actually right angles. Therefore, the receding sets of parallel edges of the object appear to converge toward vanishing points on the vanishing trace, above and below the level horizon line.

The distance from the center of vision to the point marked X, in Figure 144, is equal to that of the eye or station point from the center of vision.

2. Uphill Views (in Parallel Perspective)

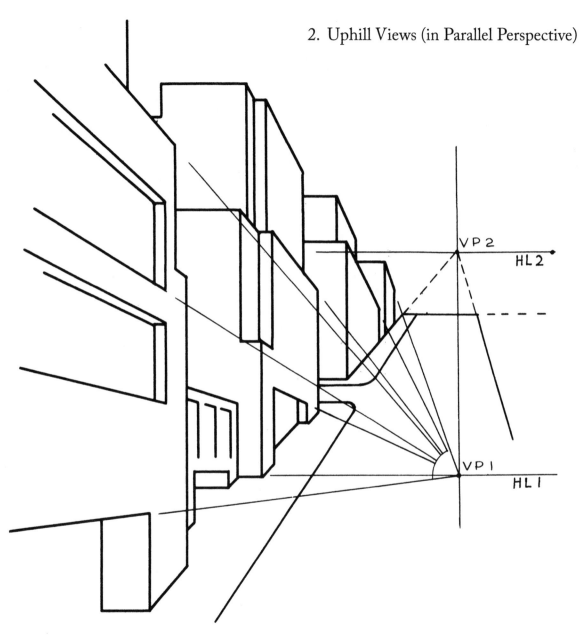

Study the relation of the two horizon lines in Figure 145. Note: The edges of the floors, being level, will converge toward a point on the first horizon line (HL1), which is the normal eye level. The street is the inclined plane, and would, if extended, disappear on its own horizon line (HL2).

Figure 146 is a diagrammatic vertical section which indicates the structural relationship of the street and buildings to an imaginary level ground surface, as viewed from the right side of the street.

Fig. 145. Street scene: uphill view in parallel perspective

Fig. 146. Elevation (as seen from the right) of floors and street in the accompanying uphill view (see Fig. 145)

TO VPL

UNDER-SURFACE
OF FLOOR

TO VPR >

EYE LEVEL

Fig. 147. Uphill view in a natural setting

In this interesting uphill view, the house, which of course is level, is drawn in ordinary two-point perspective, with vanishing points on the eye level. The steep hillside, with its approximately parallel banks, is irregular. The road represents a fairly plane surface inclined slightly upward; the extensions of its roughly parallel edges, if straight instead of winding, would meet at the left, on a second horizon line above the eye level.

3. Downhill Views (in Parallel Perspective)

Fig. 148. right). Vanishing points of two singly inclined planes and a level plane

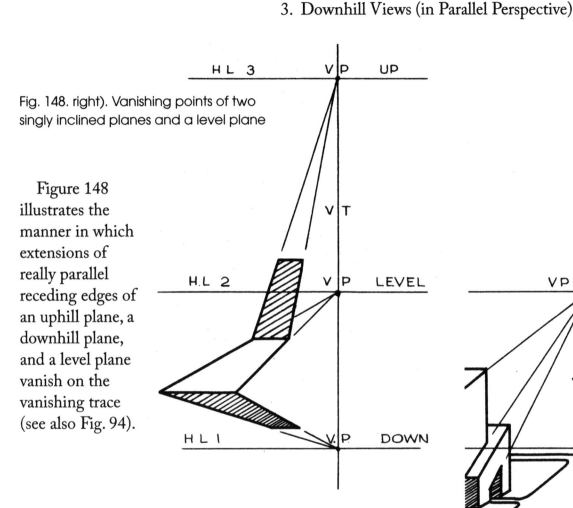

Figure 148 illustrates the manner in which extensions of really parallel receding edges of an uphill plane, a downhill plane, and a level plane vanish on the vanishing trace (see also Fig. 94).

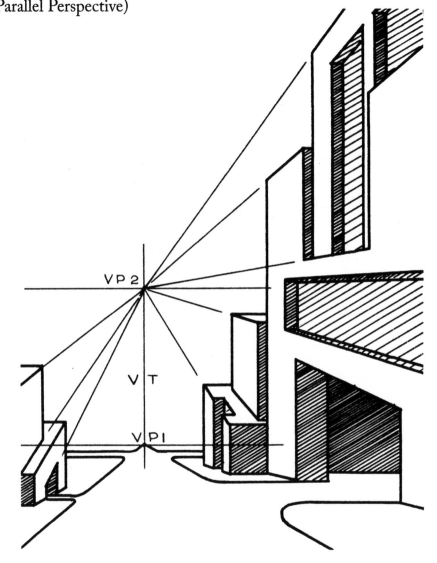

Fig. 149. Downhill view, parallel perspective

Study Figure 149 carefully. Note that, because the floors and roofs are known to be level (compare with Figs. 145 and 147), the lines extended from their parallel receding edges converge toward a point (VP2) on the normal eye level. The street is the inclined plane, and its edges vanish at a point (VP1) on a horizon line *below* eye level. Both vanishing points are on the vanishing trace.

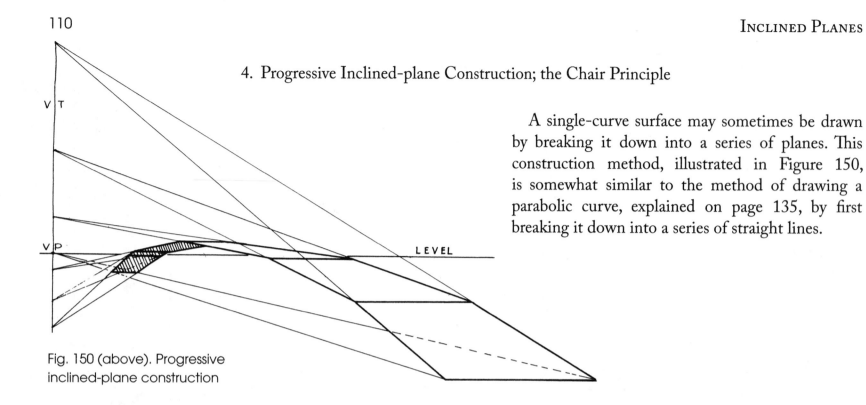

4. Progressive Inclined-plane Construction; the Chair Principle

A single-curve surface may sometimes be drawn by breaking it down into a series of planes. This construction method, illustrated in Figure 150, is somewhat similar to the method of drawing a parabolic curve, explained on page 135, by first breaking it down into a series of straight lines.

Fig. 150 (above). Progressive inclined-plane construction

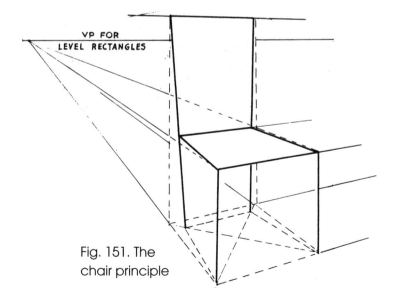

Fig. 151. The chair principle

In drawing a chair with a back which has nonparallel edges and also is slightly inclined, a combination of construction methods may be used, as in Figure 151.

Observe the position of the resting points of the rear legs in relation to the rectangular level plane containing these points. Observe also the position of the back of the level seat in relation to the front. Note that on each side the four points representing the two feet and the two seat corners do not lie in the same plane.

If the seat were not level, an additional complication would be introduced and the preliminary construction would have to be further modified.

IX. THE CIRCLE AND THE ELLIPSE

1. Ellipse Construction

The difficulty of drawing a foreshortened circle, which is an ellipse, may be lessened by first enclosing the circle in a square and projecting it. *To draw an ellipse, eight points are needed;* these points are shown in the circle plan, Figure 152. Note that a diagonal of the square of one-fourth of the base of the large circumscribed square gives the unit of measure for locating the points where the circle intersects the diagonals of the larger square; though not needed for finding these intersections on the plan, this measure is useful in locating the same eight points on a foreshortened circle (see Figs. 153, 154).

Study Figure 153, which shows a foreshortened circle centered (on the vertical through CV), or true ellipse. *The major axis of a true ellipse is always perpendicular to its minor axis.* In this figure, note that the major axis, A - A, is horizontal. Since two sides of the enclosing square are parallel to the ground line, a horizontal line, D - D, *through the true center of the circle* coincides with the diameter connecting the actual midpoints of the receding sides of the square; this horizontal diameter lies beyond and is shorter than the major axis, A - A. Here, these two lines are *strictly* parallel.

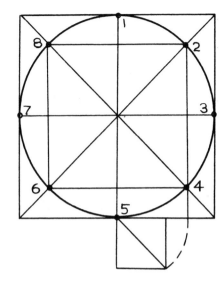

Fig. 152 (above). Circle plan

In rendering a level foreshortened circle seen from one side (Fig. 154), we deviate from strict, scientific perspective. *Actually, the major and minor axes of the ellipse are somewhat tilted, but visually we do not accept such distortion. The level circle is therefore drawn as a horizontal ellipse* (regardless of the position of the enclosing square [compare Figs. 154, 130, 163]; but with such a square as in Fig. 154, the ends of the horizontal diameter must be points of tangency).

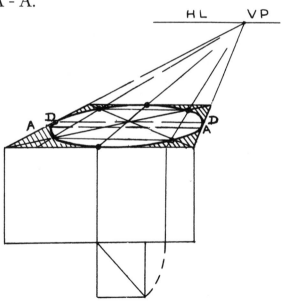

Fig. 154. Foreshortened circle on a level plane, uncentered

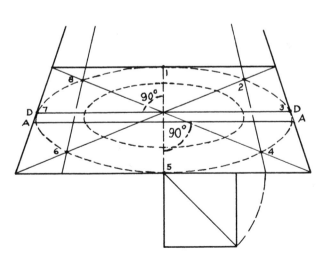

Fig. 153. Foreshortened circle on a level plane, centered

111

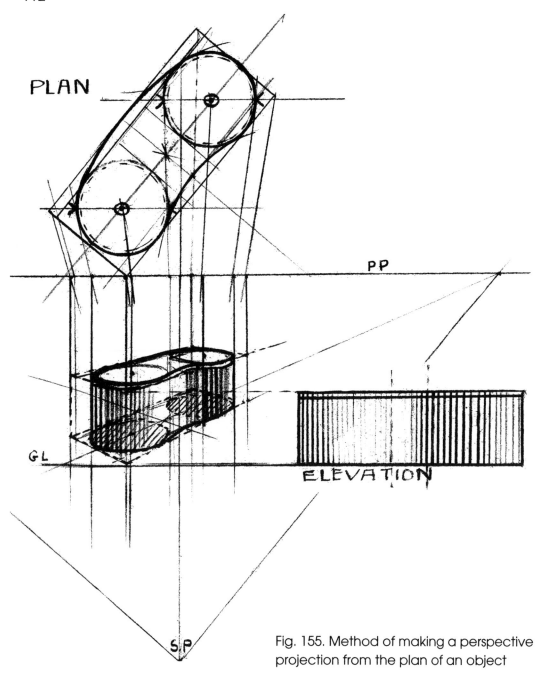

PLAN

PP

GL

ELEVATION

SP

Fig. 155. Method of making a perspective projection from the plan of an object

2. Plan, Elevation, Perspective Projection

Apply the general principles of projecting a perspective view of the enclosing rectangle, as described on page 89.

The points of tangency marked > and the true centers, when located in the perspective rectangle below, will enable you to construct the two circles in the plan as perspective ellipses. They will also reduce relatively and automatically, according to the principles of foreshortening.

If we can transfer one point in the plan to a corresponding location in the perspective drawing, we can locate any other point. Therefore, *irregular* or *abstract* forms can be drawn by using this principle.

Use your inventiveness in making designs, and give them concreteness by transmuting them into three-dimensional forms. In other words, develop your own creations!

In Figures 156 and 157, practical use is made of opposite features of an ellipse. These points are found by passing a diagonal through the horizontal diameter of the foreshortened circle (see also Figs. 23 and 153).

Fig. 156. Plan of a circular pitcher

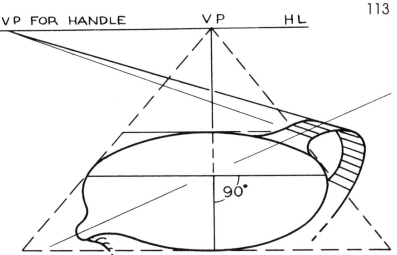

Fig. 157. Perspective projection of circular pitcher top shown in Figure 156

Important: Study the principle of the increase in depth or of the increase in the length of the minor axes, of the ellipses in Figure 158, proceeding downward from the horizon line.

In general, this principle applies also to an increase in the distance to the left or right of the line of sight (but see, on pp. 114 and 115, special rules governing ellipses on vertical surfaces seen in two-point perspective).

By turning Figure 158 upside down and assuming the entire object now to be above the eye level, it will be seen that the same principle applies.

(For the use of this principle in spherical construction, see pages 121 and 122.)

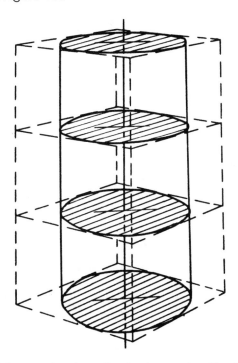

Fig. 158. Increasing length of minor axis of horizontal ellipse as distance from horizon line increases

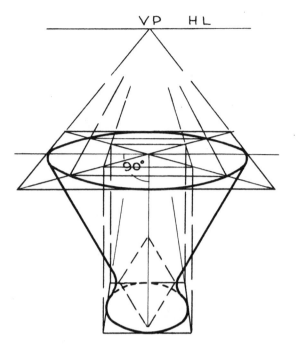

Fig. 159. Cones with same axis

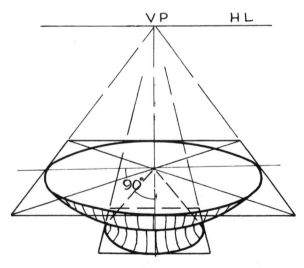

Fig. 160. Common vertical axis

3. The Axis of Rotation

The axis of rotation is an imaginary line at right angles to the plane on which the ellipse is drawn, and intersects that plane at the true center of the perspectively drawn circle. Figure 159 is an example of an upright cone and an inverted cone revolving about a common axis. In Figure 160 the same principle is illustrated with a differently derived figure.

In two-point perspective, the axis of rotation extends to the vanishing point of the extensions of parallel edges of planes perpendicular to the plane on which the ellipse is drawn. The minor axis of any ellipse appears to be coincident with that part of the axis of rotation which is behind the ellipse; therefore the axis of rotation may be located by extending the minor axis to the opposite vanishing point (see Figs. 161 and 162).

(This principle, properly modified, applies similarly to horizontal planes and vertical axes of rotation.)

Note the *leaning character* of the ellipses on vertical surfaces in Figures 161 and 162.

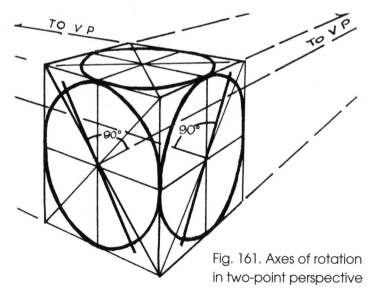

Fig. 161. Axes of rotation in two-point perspective

A practical application of the principle of the leaning ellipse is illustrated in Figure 162; here, the two axes of rotation lie *above* the eye level (compare with Fig. 161).

Fig. 162. Vertical ellipses in two-point perspective, with axes of rotation above the horizon line

Fig. 163 (below). Axis of rotation of an ellipse on a horizontal plane, and relation to enclosing figure

Fig. 164. Oblique section of cylinder

In one-point or two-point perspective, the major axis of an ellipse on a level plane (see Fig. 163) will always remain parallel to the base of the picture, regardless of the vanishing direction taken by the receding edges of its enclosing figure.

If a vertical cylinder be cut by a singly inclined plane, as in the illustration (Fig. 164), the resulting oblique form will be an oval and will be drawn foreshortened in elliptical fashion; *but* the angle formed by the long axis of the oval and the cylindrical axis will be congruent with the angle of inclination.

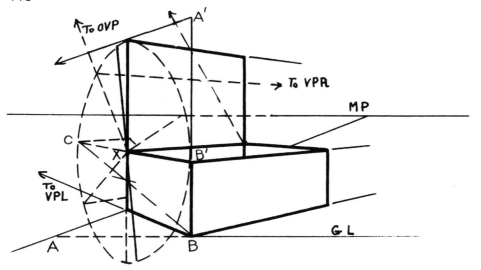

Fig. 165 (above). Measuring depths for moving plane

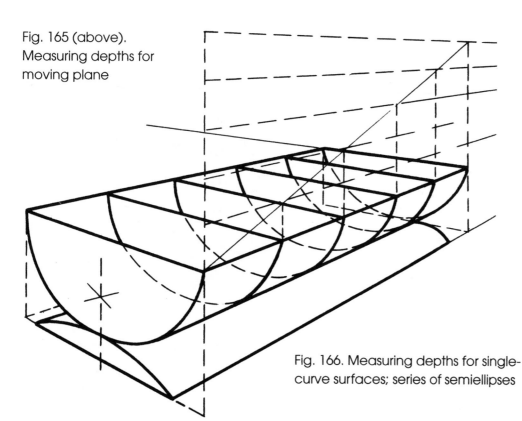

Fig. 166. Measuring depths for single-curve surfaces; series of semiellipses

4. Measuring Depths for Moving Planes

The method of measuring depths for moving planes is used in drawing such things as lids, covers of books, and doors. It is obviously important to convince the observer that the moving plane has the same dimensions as those of the corresponding aperture, as is illustrated in Figure 165. The ellipse in this drawing indicates the path traveled by an outside corner of the moving lid. The true depth of the lid may be found by using a measuring point (see Fig. 95 and text, p. 78). In Figure 165, AB = A'B', and B'X = CX.

5. Measuring Depths for Single-curve Surfaces

In Figure 166, the divisions of the long receding rectangle may be found by the use of the diagonal method of measuring depths (see p. 101), and semiellipses may thus be constructed. See also the discussions and illustrations of the box construction method on the facing page and of the semicircular plan on page 118.

6. Box Construction

For measuring depths of vaults the principle of box construction should be used, as in Figure 167.

In the representation of objects of complex design, such as those in Figure 168, below, box construction proves helpful in establishing the axes of ellipses (see also p. 111) and in drawing plane surfaces and curved surfaces seen in perspective (compare these with other examples of box construction on pp. 24 and 93).

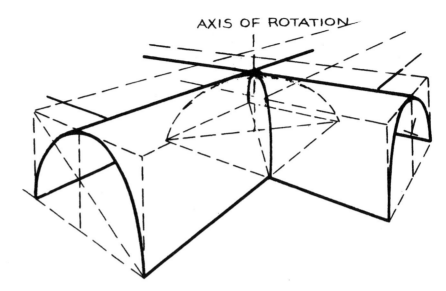

AXIS OF ROTATION

Fig. 167 (above). Measuring depths of vaults

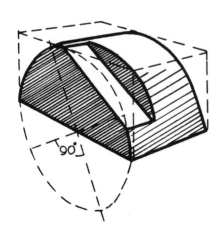
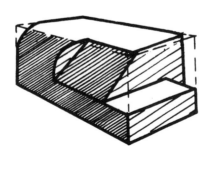
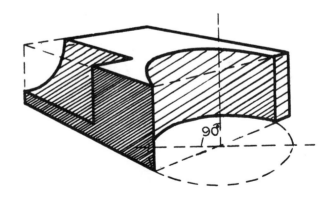

Fig. 168. Box construction for composite figures with both plane and single-curve surfaces

7. The Semicircular Plan

Figures 169 and 170 show exact and approximate methods of measuring depths in perspective on curved surfaces.

These methods may be used for locating ornament or design in perspective on single- and double-curve objects by the addition of further ellipses, thus forming surface compartments.

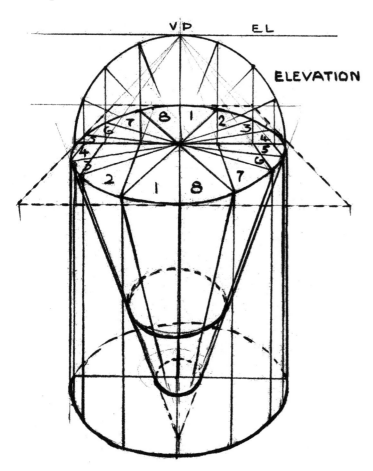

Fig. 169. Measuring depths on a single-curve object

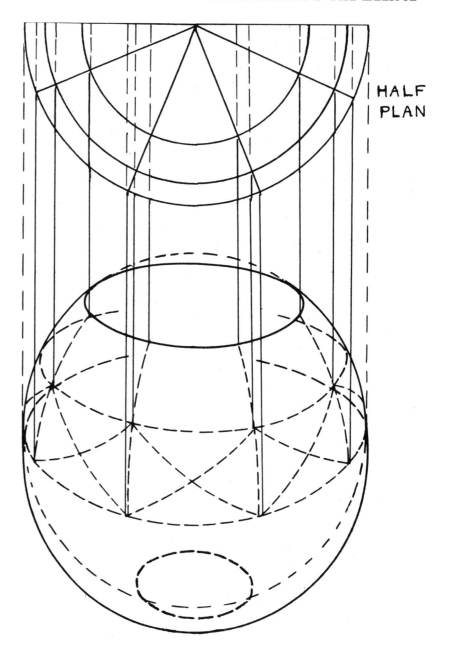

Fig. 170. Measuring depths on a double-curve object

8. Cylindrical Direction

In Figure 171, it should be noted that the angles A, B, and C are apparently equal. The line direction of each object is manifested mainly by ellipse construction, based upon relative axial changes and upon the relationship of each part of the object to the horizon line and to the center of vision.

In Figure 172, line direction and axial changes are further illustrated. The position of the horizon line and the center of vision should be considered in the construction of cylindrical and conical objects.

The art student will find that the principle of cylindrical direction, as illustrated in Figure 172, will help him in the foreshortening necessary in drawing the human figure as well as cylindrical objects, for in all these forms the manifestation of axial direction is very essential (see pp. 36, 37, 48, and 49).

Fig. 172. Irregular object with changes in axial and line direction indicated by elliptical forms

Fig. 171. Axial direction in regular cylinders

9. Spiral Planes

Spiral planes may be constructed by the projection method, as shown in Figure 173.

The radii of the foreshortened circle on the ground are found by projecting lines downward from a true semicircle constructed on the horizontal diameter (the horizontal line through the true center) of the perspectively drawn circle. (Use a protractor, or the trial and error method, to subdivide the vertical semicircle into the desired number of equal parts.) An elevation and a true height line are thus found and are divided into equal units, which will represent the heights of the vertical planes. The depths of the spiral planes may then be projected.

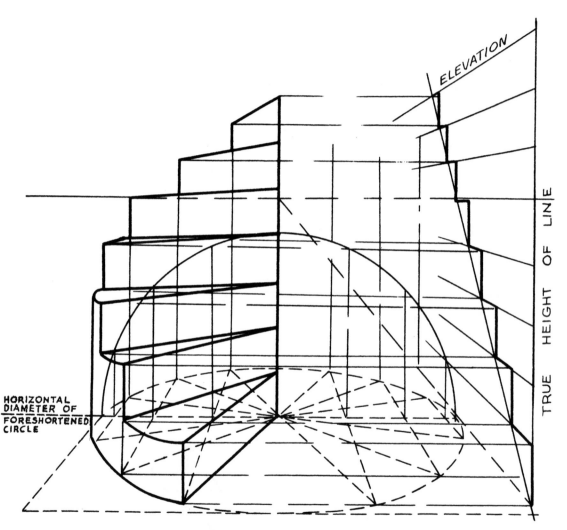

Fig. 173. The construction of spiral planes

X. THE SPHERE

SPHERE A

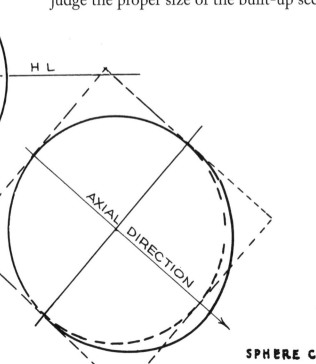

SPHERE B

1. Sphere Distortion and Axial Direction

There will be no distortion of a sphere if its axial *center* intersects the horizon line at the center of vision, as in Sphere B of Figure 174.

The perspective aspects of a sphere cause distortion. A "built-up" part will appear, varying according to distance from the station point and from a vertical through the center of vision, and also according to the axial direction.

In Sphere A and Sphere C of Figure 174, a square encloses the true circle; the built-up section is in a direction away from the observer, as the two spheres are at the left and right of the vertical through the center of vision, and above and below the horizon line, respectively.

Experience and practice will enable the student to judge the proper size of the built-up section.

Fig. 174. Diagrams of three spheres, two of which represent sphere distortion

SPHERE C

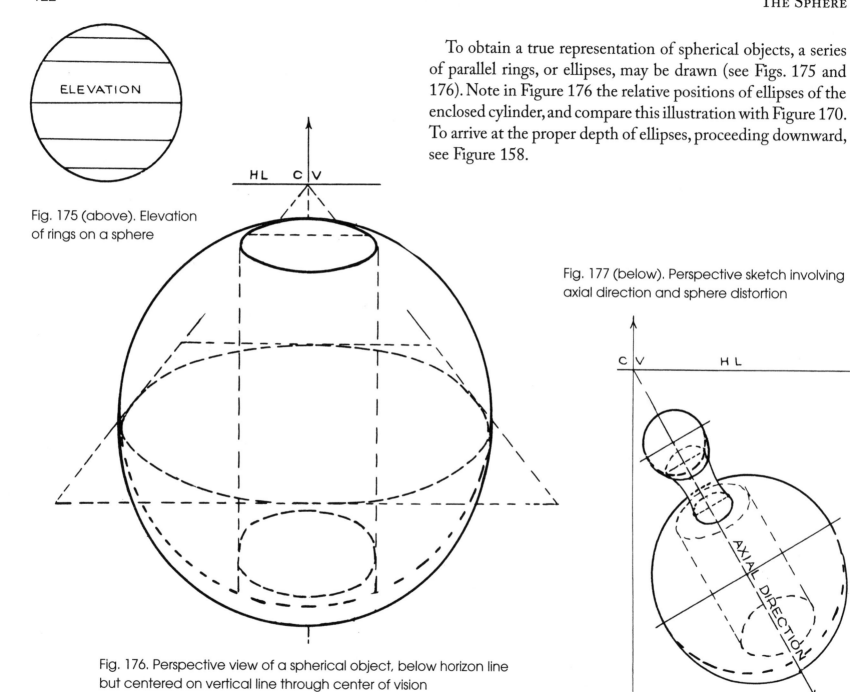

ELEVATION

Fig. 175 (above). Elevation
of rings on a sphere

HL C|V

To obtain a true representation of spherical objects, a series
of parallel rings, or ellipses, may be drawn (see Figs. 175 and
176). Note in Figure 176 the relative positions of ellipses of the
enclosed cylinder, and compare this illustration with Figure 170.
To arrive at the proper depth of ellipses, proceeding downward,
see Figure 158.

Fig. 177 (below). Perspective sketch involving
axial direction and sphere distortion

C|V H L

AXIAL DIRECTION

Fig. 176. Perspective view of a spherical object, below horizon line
but centered on vertical line through center of vision

XI. SHADOWS

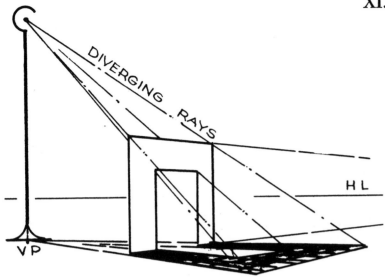

Fig. 178 (above). A shadow of an object in artificial light

1. Definition

A shadow is an area of reduced light. The dimensions of a shadow are dependent on the source of light, the kind of light, the dimensions of the object casting the shadow, and the nature of the receiving surface.

2. Natural and Artificial Light

There are two kinds of light: natural and artificial.

Ray direction is optional; usually, rays meeting a level surface at an angle of approximately 45 degrees are satisfactory for drawing purposes.

The accompanying drawings show the differences between natural light and artificial light.

Note that in Figure 178 the shadow edges extending toward the source of light converge toward a point *under* the light. Turn this figure upside down for the shadow projected by an object above the light source.

Note that under natural light (Fig. 179) the shadow edges corresponding to the vertical edges of the object casting the shadow will converge toward a point *under* the light, but *on the horizon line*. However, the sun may also be behind the observer, or elsewhere. In any case, the lines of one set of shadow edges will converge toward a point under the sun.

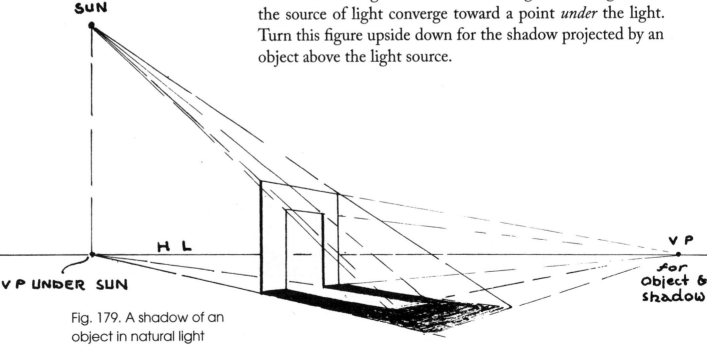

Fig. 179. A shadow of an object in natural light

123

In the following shadow principles, with one exception (No. 3), natural light rays are assumed to be parallel.

Shadow Principle No. 1

Under natural light, shadows of actually parallel edges will lie actually parallel to one another on the same plane surface or on parallel plane surfaces (see Fig. 180).

In perspective, the corresponding receding parallel edges of the object and its shadow converge toward the same vanishing point.

Shadow Principle No. 2

The direction of an actual shadow line of a given edge falling on several nonparallel receiving planes is affected by the inclination of each receiving plane (as well as by light direction and inclination of that edge).

If, as in Figure 181, a shadow line is perpendicular to the intersection line of two receiving planes, the actual angle of its change of direction at the intersection will equal the actual angle of intersection of those planes.

3. Shadow Principles

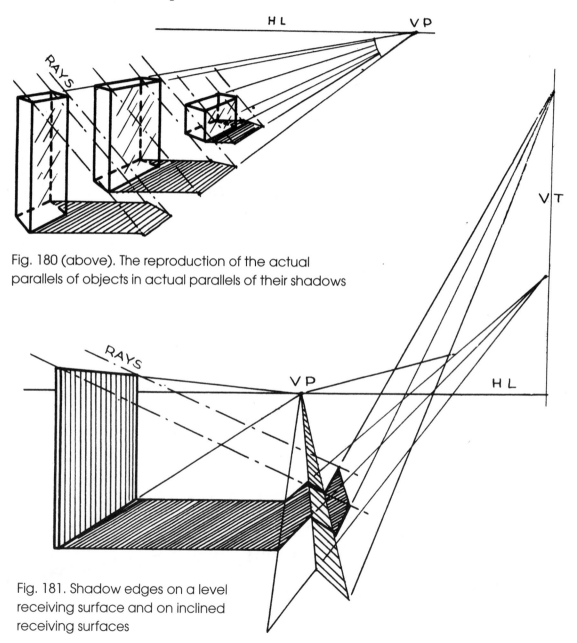

Fig. 180 (above). The reproduction of the actual parallels of objects in actual parallels of their shadows

Fig. 181. Shadow edges on a level receiving surface and on inclined receiving surfaces

Shadow Principle No. 3

The direction of light rays from any point of an object will mark the corresponding point in its shadow (see Fig. 182). If the sun or moon is near the horizon line, whatever be the position of the observer, the light rays may be treated as are the rays of artificial light, except that the vanishing points of shadow edges will be on the horizon line (see p. 123). The actually parallel receding shadow edges of one set will, as usual, converge toward a point on the horizon line immediately under the light source. Lines comprising the other set of receding parallels of both the object and its shadow will converge toward a common vanishing point on the horizon.

Shadow Principle No. 4

Method of finding a shadow point: Draw a vertical line from the point on the object to the receiving surface. From the base of this vertical, draw another line along the receiving surface, in the same

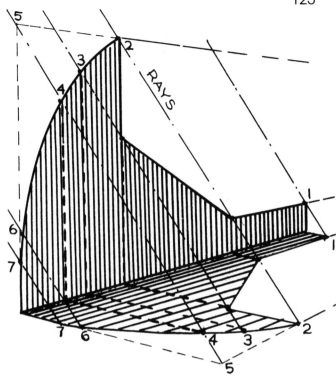

Fig. 182. Method of locating points on a shadow corresponding to points on the object casting the shadow

direction as a shadow edge corresponding to that vertical. Then draw the light ray that passes through the original point on the object. The intersection of this light ray and the line extending along the receiving surface from the base of the vertical construction line will be the shadow point which corresponds to the original point on the object.

Shadow Principle No. 5

The darkest part of a shadow is the part nearest the source of light (see Fig. 183).

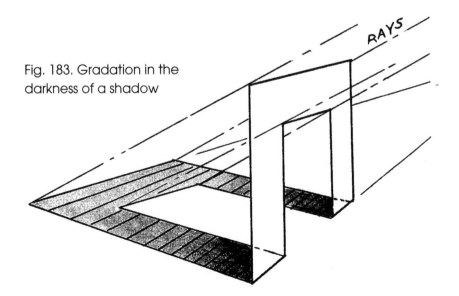

Fig. 183. Gradation in the darkness of a shadow

4. Shadows of Curved Surfaces and Curved Edges

Figures 184 and 185 illustrate the fact that the foregoing shadow principles apply equally well to single-curve surfaces and curved edges. Points on arcs of the object may be located on the receiving surface through the use of the shadow principles.

In Figure 184, the vanishing line A and its corresponding line A' in the shadow vanish at the same point.

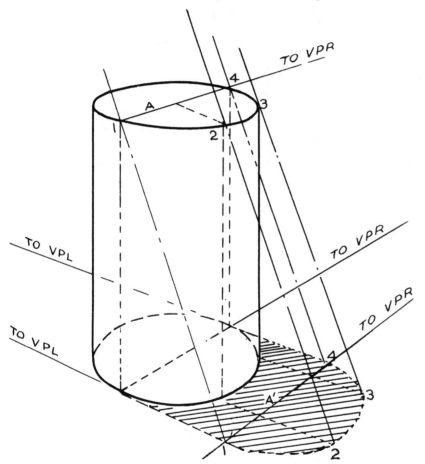

Fig. 184. The shadow cast by an object having a single-curve surface

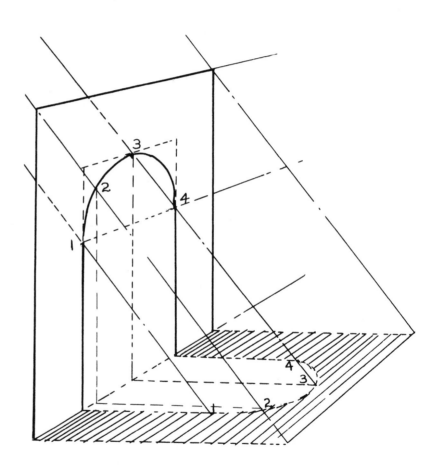

Fig. 185. The shadow corresponding to the curved edge of a plane surface

5. The Shadow Cast by an Object Parallel to the Ground Plane

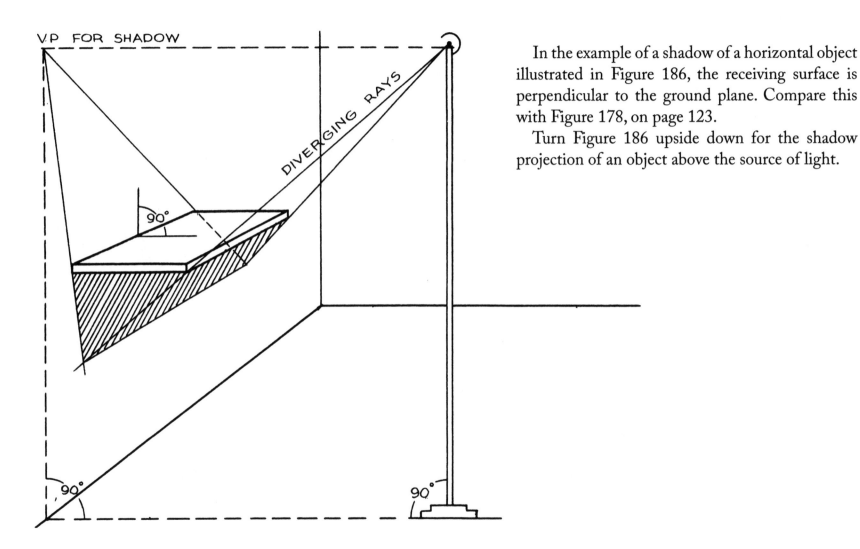

V.P FOR SHADOW

DIVERGING RAYS

90°

90°

90°

In the example of a shadow of a horizontal object illustrated in Figure 186, the receiving surface is perpendicular to the ground plane. Compare this with Figure 178, on page 123.

Turn Figure 186 upside down for the shadow projection of an object above the source of light.

Fig. 186. A shadow cast on a vertical surface by a horizontal object
(an object the largest plane surfaces of which are parallel to the ground plane)

XII. REFLECTIONS

1. The Theory of Reflections

The angle of reflection is equal to the angle of incidence (see Fig. 187).

2. Rules for Reflections

Rule No. 1. A reflected point is always beneath the corresponding point on the object and lies on a vertical line drawn from that point on the object. It is as far below the reflecting surface as the point on the object is above the reflecting surface (see Figs. 188 and 189).

Rule No. 2. The image of an object is found by connecting the essential points established on the reflecting surface (see Fig. 189).

Rule No. 3. The reflection of an object leaning toward or away from the observer may be found by doubling the distance from the object-point to the corresponding point on the reflecting surface and laying this double distance along the vertical line, according to Rule No.1 above (see Fig. 190).

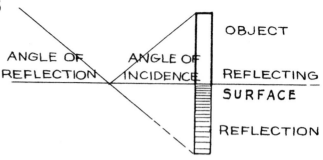

Fig. 187 (above). Angles of incidence and reflection

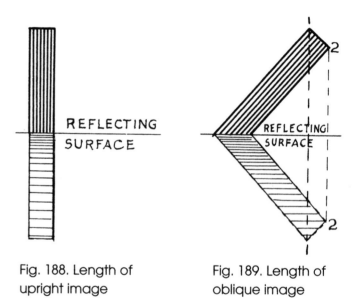

Fig. 188. Length of upright image

Fig. 189. Length of oblique image

Rule No. 4. Corresponding receding lines of each set of parallels in the reflection and in the object have the same vanishing points (see Fig. 190).

These rules apply to objects reflected in a mirror which is either parallel or perpendicular to the ground plane.

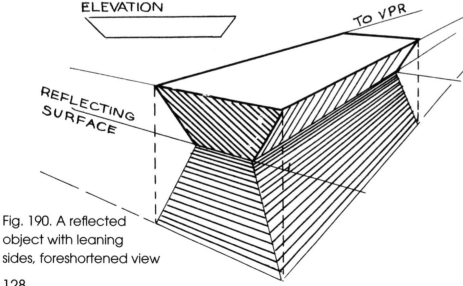

Fig. 190. A reflected object with leaning sides, foreshortened view

128

XIII. GEOMETRY REVIEW

1. Definitions and Classifications

The student of perspective will find it to his advantage to review plane and solid geometry, which will enable him to achieve results in drawing quickly and accurately.

Lines: A geometric line is one generated by a point moving according to a law

Two-dimensional Forms, or Surfaces: A geometric surface is a geometric magnitude having two dimensions

Three-dimensional Forms, or Geometric Solids: Solids which are bounded by geometric surfaces are geometric solids

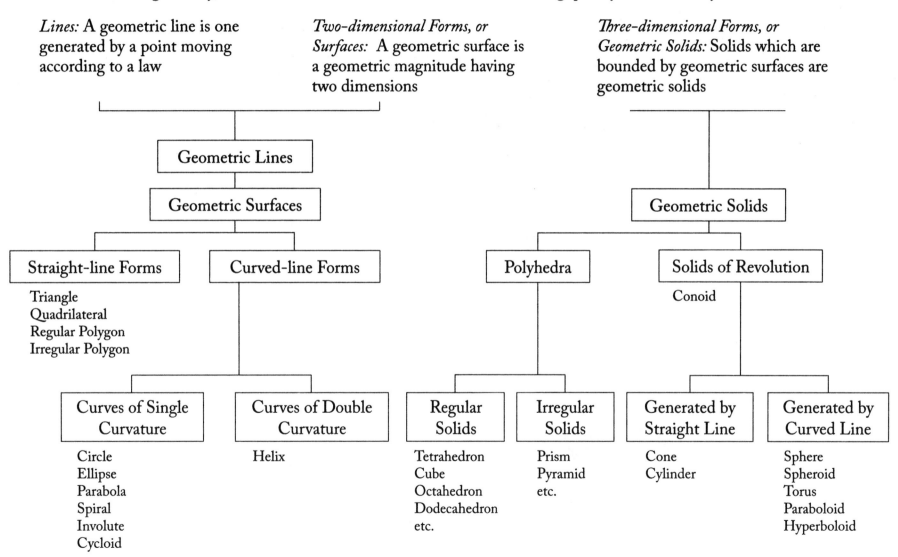

Geometric Lines

Geometric Surfaces

Geometric Solids

Straight-line Forms
Triangle
Quadrilateral
Regular Polygon
Irregular Polygon

Curved-line Forms

Polyhedra

Solids of Revolution
Conoid

Curves of Single Curvature
Circle
Ellipse
Parabola
Spiral
Involute
Cycloid

Curves of Double Curvature
Helix

Regular Solids
Tetrahedron
Cube
Octahedron
Dodecahedron
etc.

Irregular Solids
Prism
Pyramid
etc.

Generated by Straight Line
Cone
Cylinder

Generated by Curved Line
Sphere
Spheroid
Torus
Paraboloid
Hyperboloid

2. Illustrations of the Principal Geometric Forms in Two Dimensions

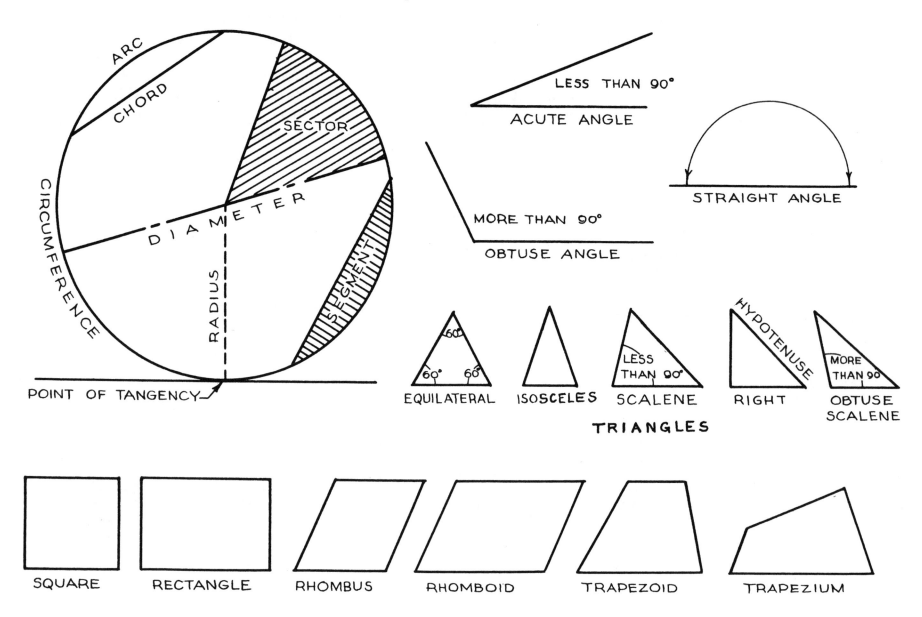

Fig. 191. Principal geometric forms in two dimensions

3. Illustrations of the Principal Geometric Forms in Three Dimensions

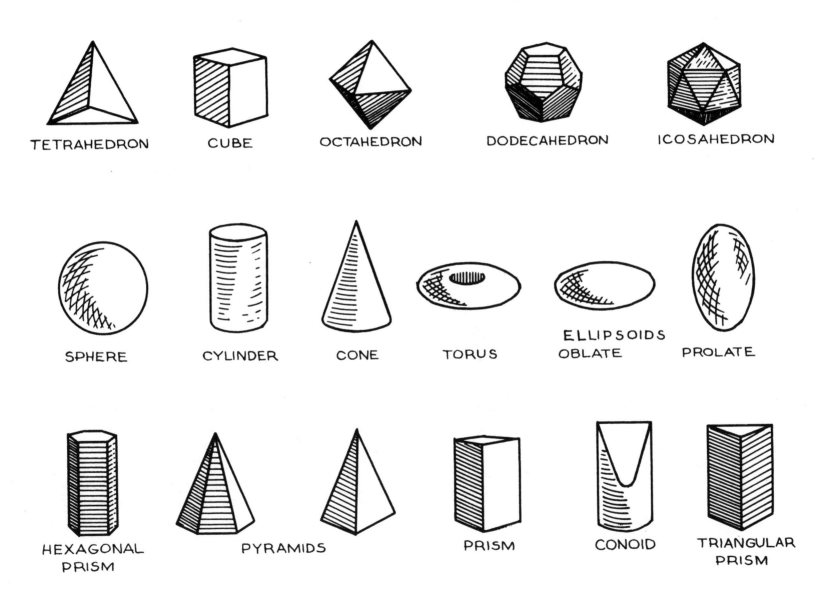

TETRAHEDRON CUBE OCTAHEDRON DODECAHEDRON ICOSAHEDRON

SPHERE CYLINDER CONE TORUS ELLIPSOIDS OBLATE PROLATE

HEXAGONAL PRISM PYRAMIDS PRISM CONOID TRIANGULAR PRISM

Fig. 192. Principal geometric forms in three dimensions

4. Construction of Regular Polygons

Definition: A regular polygon is one which is both equilateral and equiangular.

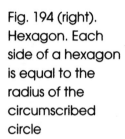

Fig. 194 (right). Hexagon. Each side of a hexagon is equal to the radius of the circumscribed circle

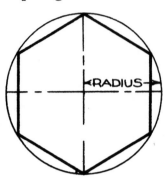

Fig. 193. Equilateral triangle. With A and B as centers and AB as a radius, strike two arcs to intersect at C. Draw AC and BC

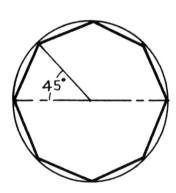

Fig. 195 (above). Octagon. From the axis construct an angle of 45 degrees on the horizontal diameter of the circumscribed circle. Mark off this distance along the circumference, and connect

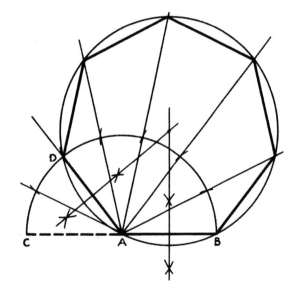

Fig. 196 (left). Method of constructing any regular polygon. AB = given side. Take this as radius of semicircle ABCD. By using a protractor or the trial and error method, divide semicircle into the required number of parts. Draw radials as indicated. AD (or second division) is always the second side of the polygon. Find the center and construct the circle as indicated. Connect the points of intersection

5. Methods of Dividing Lines into Equal or Proportionate Parts, Finding Centers, etc.

Fig. 197. Method of dividing a line (A) into equal parts

Fig. 198. Method of dividing a line (A) into proportionate parts

Fig. 199. Method of dividing a straight line in mean and extreme ratio. AB = a given line. BC = half of AB and radius of circle D. AE is laid along AB, as indicated. AX: XB forms required ratio

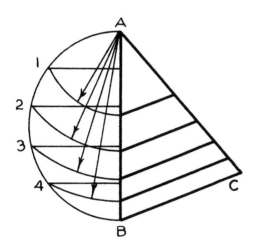

Fig. 200 (above). Method of dividing the area of any triangle (ABC) or trapezoid into equal parts. AB = diameter of semicircle. Divide AB into equal parts; extend parallels to semicircle. With A as center, connect the points 1, 2, 3, and 4 with AB, and draw parallels, as in this figure

Fig. 201 (at the right). Method of enlarging or reducing a two-dimensional figure proportionately

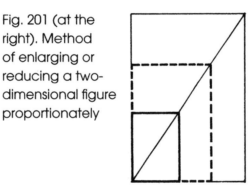

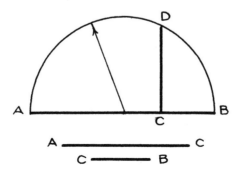

Fig. 202 (at left). Method of finding the mean proportional of two lines. The lines given are AC and BC. AC: CD = CD: CB

Fig. 203 (above). Method of finding the center of a circular object. Bisect chords. Raise perpendiculars. The point of intersection is the center of the circle

6. Some Methods of Constructing an Oval

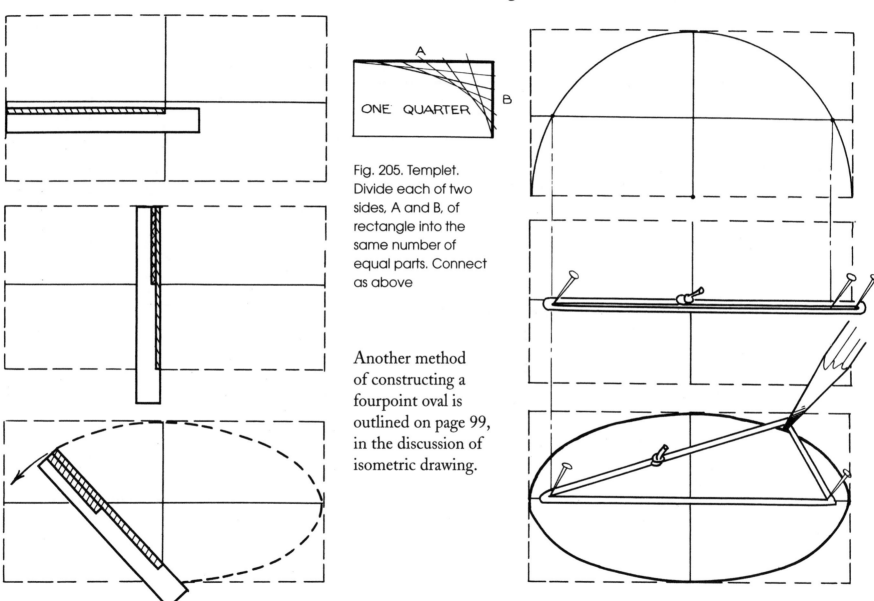

Fig. 205. Templet. Divide each of two sides, A and B, of rectangle into the same number of equal parts. Connect as above

ONE QUARTER

Another method of constructing a fourpoint oval is outlined on page 99, in the discussion of isometric drawing.

Fig. 204. The trammel method

Fig. 206. The pin-and-string method

7. The Parabolic Curve

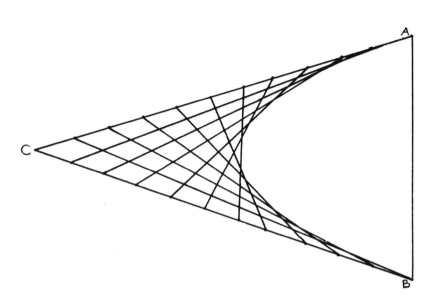

Fig. 207 (above). Method of drawing a curve similar to a parabolic curve

Fig. 208. The parabolic curve

Fig. 209. The hyperbolic curve. Compare with the true parabolic curve

Fig. 210. Method of drawing a derivative form of the parabolic curve

To join two given points A and B with an approximately parabolic curve (see Fig. 207), extend lines from those two points to converge at C, divide AC and BC into the same number of equal parts, and connect the points as illustrated.

Derivative forms of the parabolic curve, such as that in Figure 210, may be constructed by the same method. Compare Figures 207 and 210.

8. Development of Surfaces

In the construction of the surface developments illustrated below (in Figs. 211–213), the student will recognize some of the principles previously studied.

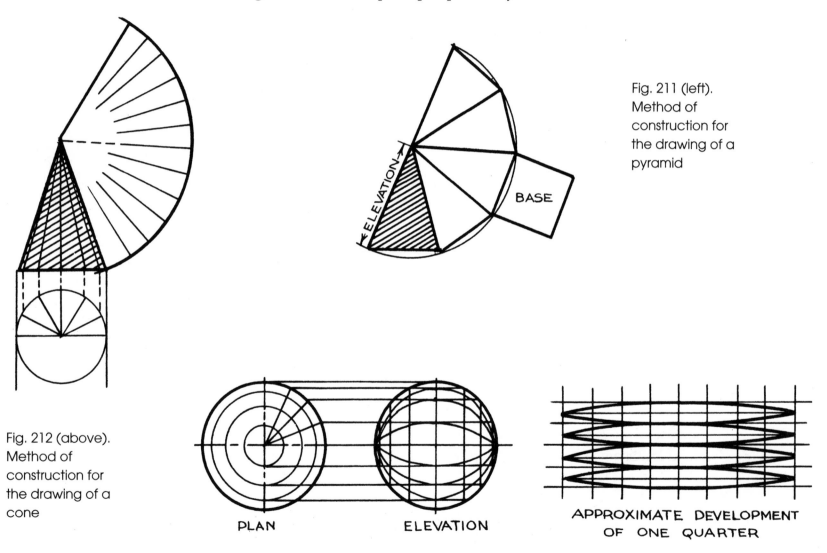

Fig. 211 (left). Method of construction for the drawing of a pyramid

BASE

Fig. 212 (above). Method of construction for the drawing of a cone

PLAN ELEVATION APPROXIMATE DEVELOPMENT OF ONE QUARTER

Fig. 213 (above). Method of construction for the drawing of a sphere

BIBLIOGRAPHY AND RECOMMENDED READING

Art Institute of Chicago. *The First Century of Printmaking.* Compiled by Elizabeth Mongan and Carl O. Schniewind. Chicago: Lakeside Press, 1941.

Clark, Arthur B. *Perspective.* Stanford, Calif.: Stanford University Press, 1936.

De Tolnay, Charles. *History and Technique of Old Master Drawings, a Handbook.* New York: H. Bittner and Co., 1943.

Dodgson, Campbell. *Modern Drawings.* New York: Studio Publications, Inc., 1933.

French, Thomas E. *Engineering Drawing.* New York: McGraw-Hill Co., 1941.

Giesecke, Frederick E., Alva Mitchell, and Henry C. Spencer. *Technical Drawing.* New York: Macmillan Co., 1940.

Guptill, A. L. *Sketching and Rendering in Pencil.* New York: Reinhold Publishing Corp., 1944. (Reprinted as *Drawing and Sketching in Pencil* by Dover Publications, Inc., Mineola, N. Y., 2007.)

Havinden, Ashley. *Line Drawing for Reproduction.* New York: Studio Publications, Inc., 1942.

Holme, Bryan, and Thomas Forman, eds. *Master Drawing.* New York and London: The Studio Publications, Inc., 1943.

Medworthy, Frank. *Perspective.* New York: Charles Scribner's Sons, 1937.

Miller, H. W. *Descriptive Geometry.* New York: J. Wiley and Sons, 1941.

Pope, Arthur. *Introduction to the Language of Drawing and Painting.* Cambridge, Mass.: Harvard University Press, 1939.

Ridgway, John L. *Scientific Illustration.* Stanford, Calif.: Stanford University Press, 1938.

The University Prints. Newton, Mass.